The Jewish Writer

Jill Krementz

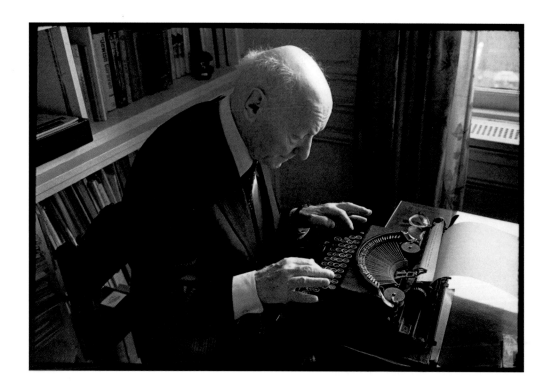

Henry Holt and Company

New York

Henry Holt and Company, Inc.
Publishers since 1866
115 West 18th Street
New York, New York 10011

Henry Holt is a registered trademark of
Henry Holt and Company, Inc.

Published in Canada by Fitzhenry & Whiteside Ltd.
195 Allstate Parkway, Markham, Ontario L3R 4T8

Library of Congress Cataloging-in-Publication Data
Krementz, Jill.
The Jewish writer/Jill Krementz. —1st American ed.
p. cm.
ISBN 0-8050-6037-5 (hardbound : alk. paper)
1. Jewish authors—United States—Portraits.
2. Authors, American—20th century—Portraits.
3. Portrait photography.
I. Title
PS153.J4K74 1998 98-20039
810.9'896—dc21 CIP

First Edition 1998

Designed by Lucy Albanese

Printed in the United States of America
All first editions are printed on acid-free paper. ∞
1 3 5 7 9 10 8 6 4 2

Photographs and compilation of text © 1998 by Jill Krementz. All rights reserved under International and Pan-American copyright conventions. Published in the United States by Henry Holt and Company, Inc., New York.

Permission to reproduce any image included in this book must be obtained in writing from Jill Krementz.

Text research: Alan Bisbort.

Grateful acknowledgment is made to those who wrote directly for this project, *The Jewish Writer:* Aharon Appelfeld, Rosellen Brown, Allegra Goodman, Tony Kushner, Robert Pinsky, Belva Plain, Letty Cottin Pogrebin, Chava Rosenfarb, Maurice Sendak, and Cheryl Pearl Sucher.

Grateful acknowledgment is made to the following for permission to reproduce photographs and/or illustrations from personal collections: Max Apple, E. L. Doctorow, Al Hirschfeld and Louise Kerz, Ricky Jay, David Kertzer, Daphne Merkin, James McBride, Letty Cottin Pogrebin, Chava Rosenfarb, Maurice Sendak, Cheryl Pearl Sucher, Calvin Trillin, and Ruth R. Wisse.

Grateful acknowledgment is made to the following for permission to reprint previously published or unpublished material: From *Art and Ardor,* by Cynthia Ozick, copyright © 1983 by Cynthia Ozick, used by permission of Alfred A. Knopf, Inc.; from *The Color of Water,* by James McBride, copyright © 1996 by James McBride, published by Riverhead Books, a division of G. P. Putnam and Sons, a division of Penguin Putnam, Inc.; "Romania, Romania," from *This Time: New and Selected Poems,* by Gerald Stern, copyright © 1998 by Gerald Stern, reprinted by permission of W. W. Norton & Company, Inc.; from *Marjorie Morningstar,* by Herman Wouk, copyright © 1955 by Herman Wouk, reprinted by permission of Doubleday, a division of Bantam Doubleday Dell Publishing Group, Inc.; unpublished letter to Jill Krementz from Norman Mailer, reprinted by permission of Norman Mailer; © Al Hirschfeld art reproduced by special arrangement with Hirschfeld's exclusive representative, the Margo Feiden Galleries Ltd., New York; from *The Far Euphrates,* by Aryeh Lev Stollman, published in 1997 by G. P. Putnam and Sons, a division of Penguin Putnam, Inc.; illustration and quote by Maurice Sendak, reprinted by permission of Maurice Sendak; from *The Kidnapping of Edgardo Mortara,* by David Kertzer, copyright © 1997 by David I. Kertzer, used by permission of Alfred A. Knopf, Inc.; from *All the Rivers Run to the Sea,* by Elie Wiesel, copyright © 1995 by Elie Wiesel, used by permission of Alfred A. Knopf, Inc.; "An Old Cracked Tune," copyright © 1971 by Stanley Kunitz, from *Passing Through: The Later Poems, New and Selected,* by Stanley Kunitz, reprinted by permission of W. W. Norton & Company, Inc.; excerpt from the poem "Silver" from the *End of Desire,* by Jill Bialosky, copyright © 1997 by Jill Bialosky, used by permission of Alfred A. Knopf, Inc.; from *Summer in Williamsburg,* by Daniel Fuchs, copyright © 1934, 1961 by Daniel Fuchs, used by permission of Carrol & Graf Publishers, Inc.; from *World's Fair,* by E. L. Doctorow, copyright © 1985 by E. L. Doctorow, used by permission of Random House, Inc.; excerpt from interview with Arthur Miller from *The Paris Review,* reprinted by permission; from "The Talmud and the Internet," by Jonathan Rosen, originally published in *The American Scholar,* reprinted by permission; from *I Love Gootie,* by Max Apple, copyright © 1998 by Yom Tov Sheyni, Inc., by permission of Warner Books, Inc., photograph courtesy of Maxine Apple Winer, K. Kreuger Jones; cover art by Ben Katchor from *Julius Knipl, Real Estate Photographer,* copyright © 1996 by Ben Katchor, reprinted by permission of Little, Brown and Company; from *Mr. Mani,* by A. B. Yehoshua, copyright © 1992 by A. B. Yehoshua, reprinted by permission of Doubleday, a division of Bantam Doubleday Dell Publishing Group, Inc.

For permission to reprint previously published or unpublished material the author wishes to thank: Yehuda Amichai, E. M. Broner, Molly Elkin, Eli N. Evans, Bruce Jay Friedman, Joseph Heller, Ricky Jay, Erica Jong, Mrs. Alfred Kazin, Phillip Lopate, Joseph Machlis, Mrs. Bernard Malamud, David Mamet, Norman Manea, Daphne Merkin, Joan Nathan, Cynthia Ozick, Grace Paley, Francine Prose, Jonathan Rosen, Philip Roth, Budd Schulberg, Calvin Trillin, and Wendy Wasserstein.

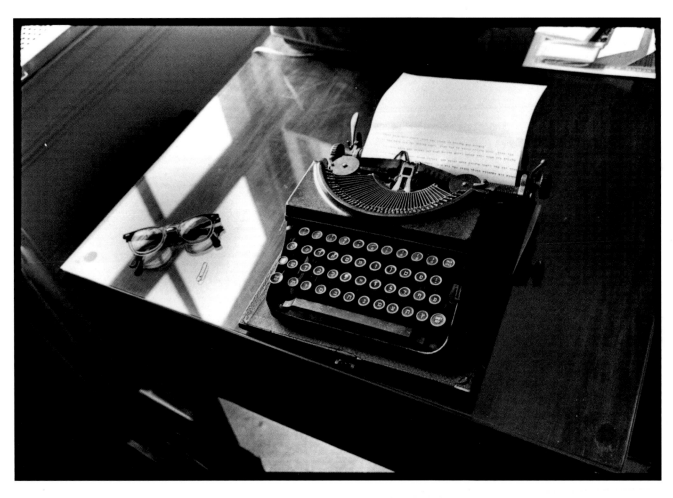

ISAAC BASHEVIS SINGER'S TYPEWRITER
New York City, October 19, 1978

This book is obviously only a sampling of the hundreds of Jewish writers who have enriched the culture of the world in the 20th century.

JK

Contents

The Jewish Writer

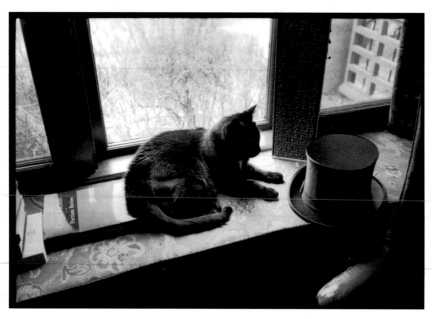

**A cat and a hat: Saul Bellow's cat, Moose,
and the top hat he wore to accept his Nobel Prize**

Saul Bellow (b. 1915) has earned every imaginable literary honor,
including the 1976 Nobel Prize in literature. The son of Russian-
Jewish immigrants, he was born in Quebec but came of age in
Chicago, speaking Yiddish at the same time as he spoke English.
Out of this cultural mix came a fascination with nineteenth-century
Russian novelists who grappled with profound truths about the
human spirit. His writing explores essential demarcations, from his
first book, *Dangling Man* (1944), about a man waiting for induction
into the army, to his most recent, *The Actual* (1997), which tells
of the retrieval of a lost love. In the novels *Herzog* (1964) and
Mr. Sammler's Planet (1970) Bellow focuses on what it means to
be a virtuous Jew in a spiritually challenged age.

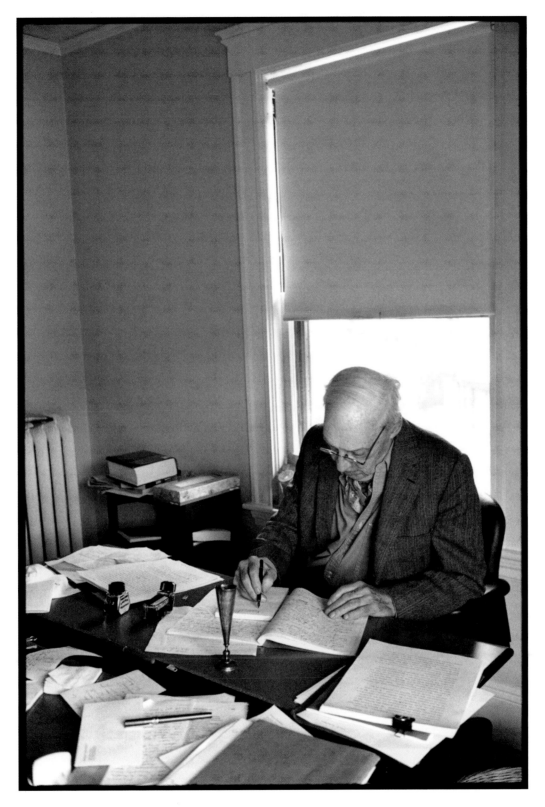

SAUL BELLOW
Brookline, Massachusetts, March 1, 1997

A liturgical literature has the configuration of
the ram's horn: you give your strength to the
inch-hole and the splendor spreads wide.

<div align="right">from Art & Ardor: Essays (1983)</div>

Cynthia Ozick (b. 1928) brings to all her work a dazzling lyricism,
magical irony, and the profoundly questioning spirit of a
rationalist temper. Her first novel, *Trust* (1966), was followed by
the story collections *The Pagan Rabbi* (1971), *Bloodshed* (1976),
and *Levitation* (1982). She has published three volumes of essays.
Her short story "Envy; or, Yiddish in America" movingly and
humorously conveys the trauma of an immigrant Yiddish poet
in anguished search of a translator. "The Shawl," a masterpiece
of Holocaust fiction, has been widely anthologized. Of her
five novels, the most recent is *The Puttermesser Papers* (1997),
a wickedly funny modern-day picaresque about a female heroine
named Puttermesser whose name means "butter knife" in Yiddish.
Schooled in the traditions of English and American literature,
Ozick's critical sensibility and its inquiries range from Jewish
history and civilization to George Eliot and Henry James.

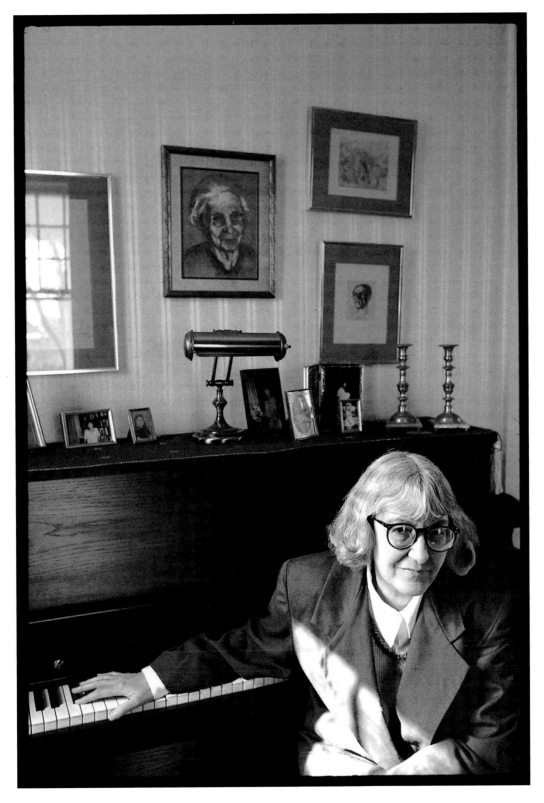

CYNTHIA OZICK
Westchester County, New York, April 1, 1997

S. J. (Sidney Joseph) Perelman (1904–1979) revolutionized
American comic prose, influencing everyone from the Marx
Brothers—for whom he wrote screenplays—to Woody Allen.
His writing style is a mix of satire, slapstick, parody, puns,
and wordplay. "There are nineteen words in Yiddish that convey
gradations of disparagement," he told an interviewer, "from a
mild, fluttery helplessness to a state of downright, irreconcilable
brutishness. All of them can be usefully employed to pinpoint
the kind of individuals I write about." In her introduction to
his anthology, *The Most of S. J. Perelman* (1958), his *New Yorker*
colleague Dorothy Parker wrote, "Mr. Perelman stands alone
in this day of humorists. Lonely he may be, but there he is."

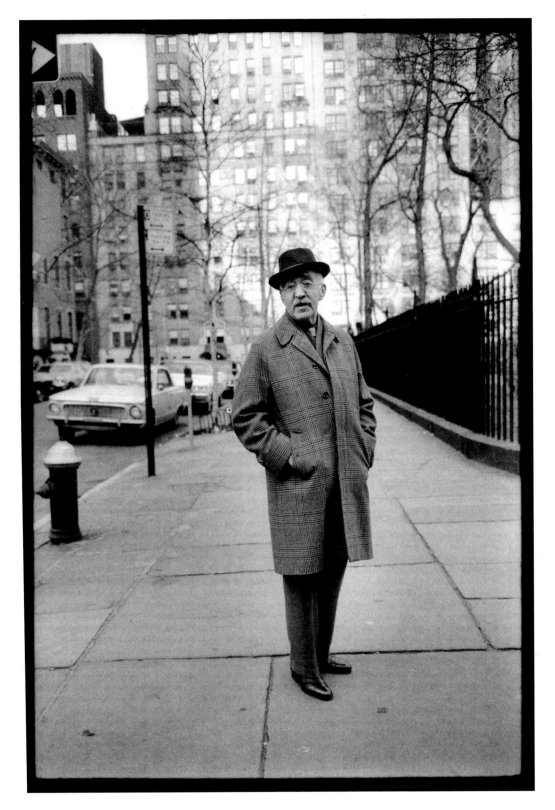

S. J. PERELMAN
Gramercy Park, New York City, February 28, 1975

Francine Prose (b. 1947) has created a richly diverse body of work—nine novels and two short-story collections—that amuses, amazes, and provokes readers. Her first novel, *Judah the Pious* (1973), tells a magical tale of a rabbi's visit to the king of Poland. A later novel, *Hungry Hearts* (1983), conjures the life of a Yiddish stage star possessed by a dybbuk. The title piece of her most recent book, a pair of novellas called *Guided Tours of Hell* (1997), is a biting satire of the contemporary literary scene in which her perfectly pitched prose follows a self-obsessed Jewish-American playwright on a visit to a concentration camp. "Jewish humor," says Prose, "plays fast and loose with self-awareness and self-pity, and with the question of when and how exactly we know which is which."

FRANCINE PROSE
New York City, September 13, 1995

Pearl Abraham (b. 1960) was raised in a Hasidic family that emigrated from Jerusalem to Williamsburg, in Brooklyn, when she was a child. Yiddish and Hebrew were her main languages until she was a teenager, and she continued to dream in Yiddish well into her twenties. The cadences of these tongues are evoked in her debut novel, *The Romance Reader* (1995), the tale of a young girl growing up in a Hasidic world and reading forbidden romance novels under her covers at night.

Her latest novel, *Giving Up America* (1998), presents a portrait of a disintegrating marriage and the cultural clash between Hasidic and secular American values.

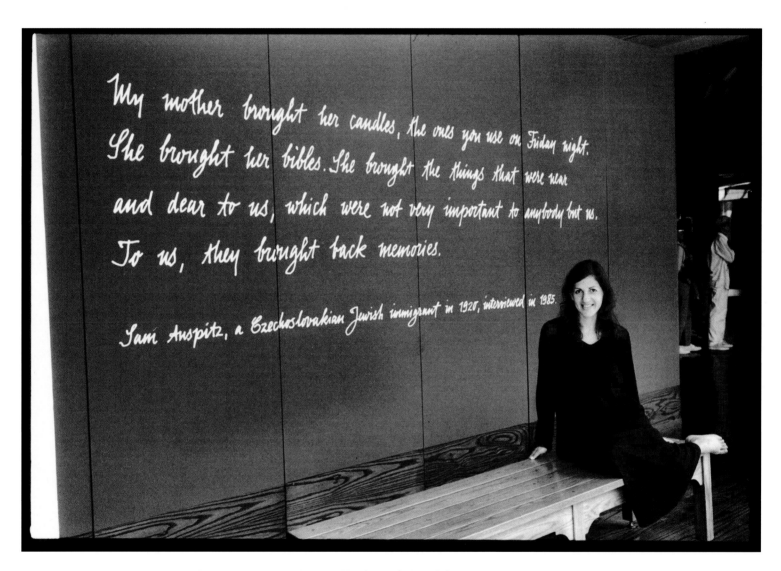

PEARL ABRAHAM
Ellis Island, New York, July 25, 1997

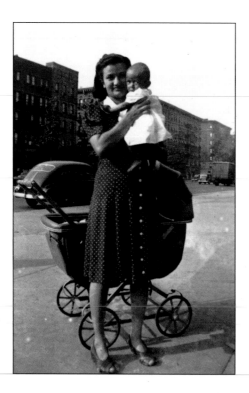

**Ruchel McBride with her
one-year-old son, Dennis
Red Hook, 1942**

Dennis was the eldest sibling and the family pioneer. . . . He was a giant among us, casting a huge oblong shadow that hung over us children like the Lincoln Memorial, which he had visited—twice. . . . Dennis had finished college. Dennis had gone to Europe. And now, for his crowning achievement, Dennis, oh glorious Dennis, oh mighty Dennis—Dennis! *Dennis!*—sought the highest, most wonderful, most incredible achievement any human being, any son, could hope to achieve.

Dennis was going to be a doctor.

from *The Color of Water*

James McBride (b. 1957) is a composer, saxophonist, journalist, and the author of an extraordinary memoir, *The Color of Water* (1996). That best-selling book, subtitled "A Black Man's Tribute to His White Mother," chronicles his coming of age in Brooklyn's Red Hook housing projects; it also uncovers the astonishing tale of his mother, a Polish rabbi's daughter named Ruchel Dwajra Zylska, who put her twelve children through college and, at age sixty-five, earned her own degree in social work administration.

McBride, interweaving the two stories, his mother's and his own, begins:

As a boy, I never knew where my mother was from—where she was born, who her parents were. When I asked, she'd say, "God made me." When I asked if she was white, she'd say, "I'm light-skinned," and change the subject Her children became doctors, professors, chemists, teachers—yet none of us even knew her maiden name until we were grown. It took me fourteen years to unearth her remarkable story.

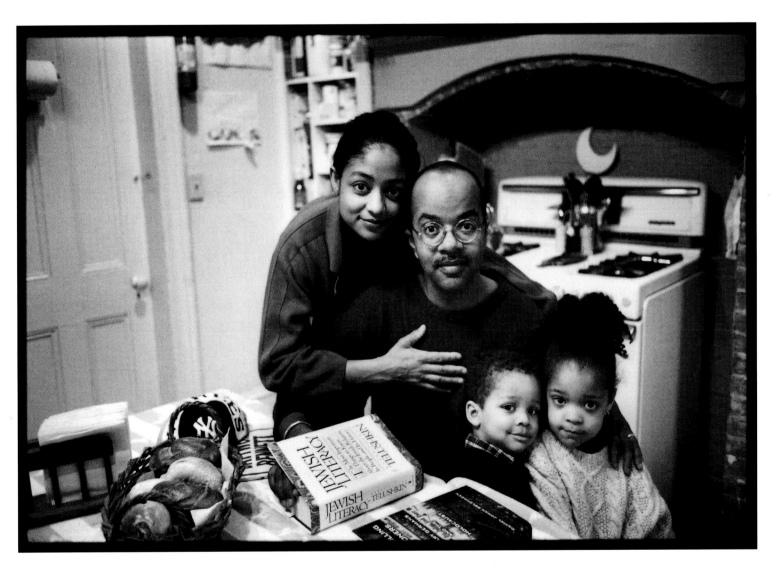

JAMES McBRIDE
with his wife, Stephanie, and children, Jordan and Azure
South Nyack, New York, March 31, 1997

Chaim Potok's writing desk: manuscript pages from
The Gates of November, **and on the reading stand,**
the Hebrew text of the *Mishnah,* **the legal code**

Chaim Potok (b. 1929) is a writer whose poignant, powerful
novels about modern Jewish life have served as inspirations for
young generations of Jews and as windows for the non-Jewish
world. Raised in an Orthodox Jewish family, Potok entered the
world of Conservative Judaism, in which he was ordained a rabbi.
The strength of his fiction comes from his own internal struggles
balancing the rigors of Talmudic scholarship with the more
imaginative pursuits of his writing. His best-selling novels
include *The Chosen* (1967), *My Name Is Asher Lev* (1972), and
Davita's Harp (1984). His most recent work is *The Gates of November:
Chronicles of the Slepak Family* (1996), a multigenerational account
of Russian Jews surviving the rise and fall of the Soviet Union.

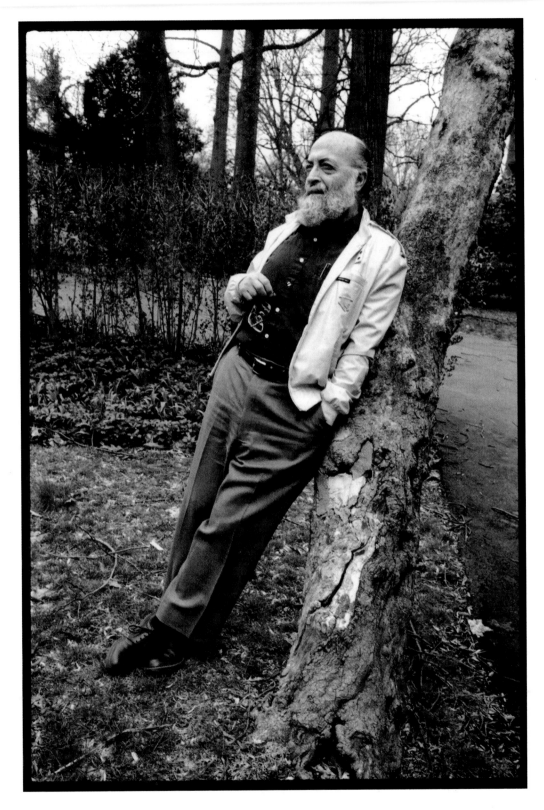

CHAIM POTOK
Merin, Pennsylvania, April 6, 1997

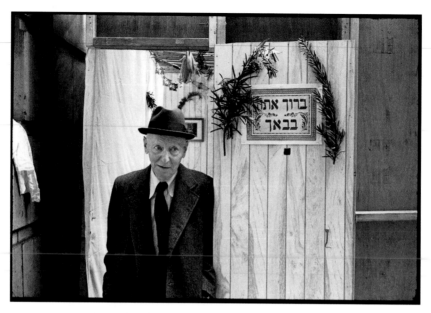

**Isaac B. Singer at his neighborhood Succah
during the fall harvest festival of Succot**

Isaac Bashevis Singer (1904–1991) won the 1978 Nobel Prize in literature for a body of work that included over a dozen novels, short-story collections, children's fables, and literary memoirs. Born to an Orthodox Jewish family in Poland, he followed his older brother Israel Joshua to America when the Nazi menace became increasingly self-evident. Once in America, he wrote for *The Jewish Daily Forward*. Exile permeated his writing, unleashing the tension between tradition and modern malaise. In novels like *Gimpel the Fool* (1957), *The Magician of Lublin* (1960), *Enemies, A Love Story* (1972), and the darkly brilliant, posthumously published *Shadows on the Hudson* (1998), Singer's work spans the chasm between the Old World and the New, lost faith, and a permanent restlessness in its place. "Life itself is a permanent crisis," he once wrote.

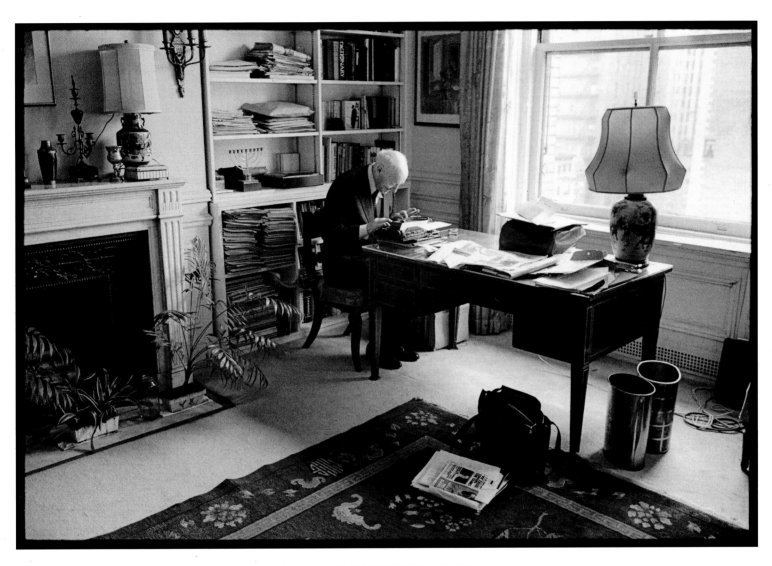

ISAAC BASHEVIS SINGER
New York City, October 19, 1978

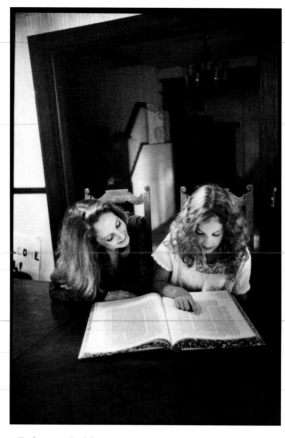

**Rebecca Goldstein and her daughter Danielle
studying the Talmud**

Rebecca Goldstein (b. 1950) is both a dedicated scholar and
literary enchanter whose writings provoke and fascinate. She is
a former professor of philosophy whose novels and short stories
dramatize conflicts between intellect and sensuality, reason and
faith, often featuring brainy women at war with their hearts.
Her first novel, *The Mind-Body Problem* (1983), is at once wildly
funny and deeply serious. More followed, including *The Dark
Sister* (1991) and *Mazel* (1995), as well as a story collection,
Strange Attractors (1993).

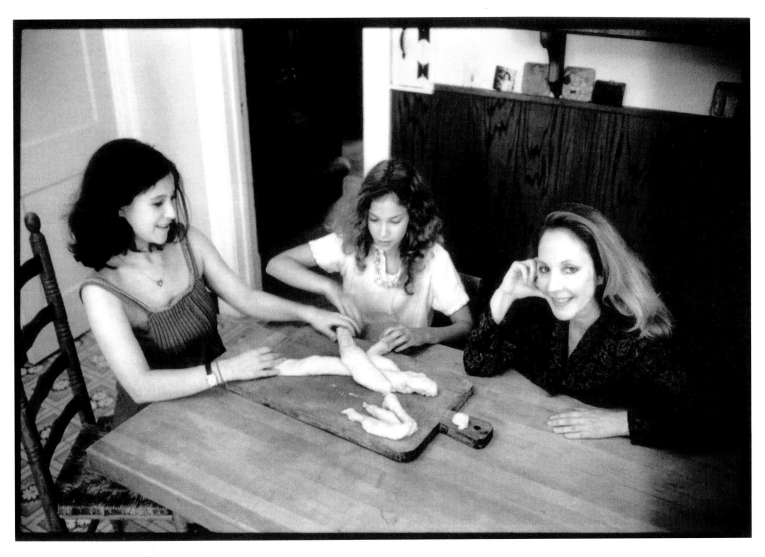

REBECCA GOLDSTEIN
with her daughters, Yael and Danielle, who are braiding challah for Sabbath
Highland Park, New Jersey, July 17, 1997

Erica Jong (b. 1942) gained instant recognition for her first novel, *Fear of Flying* (1973). An accomplished poet and writer, she has created a body of work that includes seven novels, ten collections of verse, and a memoir, *Fear of Fifty* (1994). Her most recent novel, *Inventing Memory* (1997), weaves a complex, witty, and inspiring historical saga of four generations of Jewish-American women in this century. "Maybe we've been chosen," she writes in *Inventing Memory*, "because of our abundant life force, our refusal to surrender—and maybe we should celebrate that."

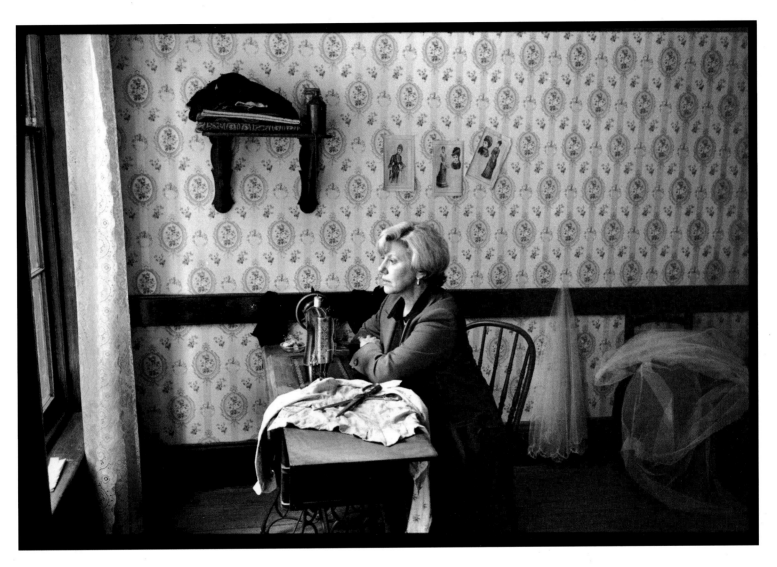

ERICA JONG
at the Lower East Side Tenement Museum
New York City, April 16, 1997

Gerald Stern with Rabbi Jacob Spiegel

Gerald Stern (b. 1925) has seamlessly blended the exaltations of everyday life with the sorrows of Jewish history in nine books of verse, including *Bread Without Sugar* (1992) and *Odd Mercy* (1995). In his poem "Romania, Romania" Stern writes:

> I stand like some country crow across the street
> from the Romanian Synagogue on Rivington Street
> singing songs about Moldavia and Bukovina.
> I am a walking violin, screeching
> a little at the heights, vibrating a little
> at the depths, plucking sadly on my rubber guts.
> It's only music that saves me.

The Roumanian Shul at 89 Rivington Street has stood for generations as a landmark of New York's Lower East Side. The voices of the great cantors still resound in the 1881 sanctuary once known as "the Cantor's Carnegie Hall."

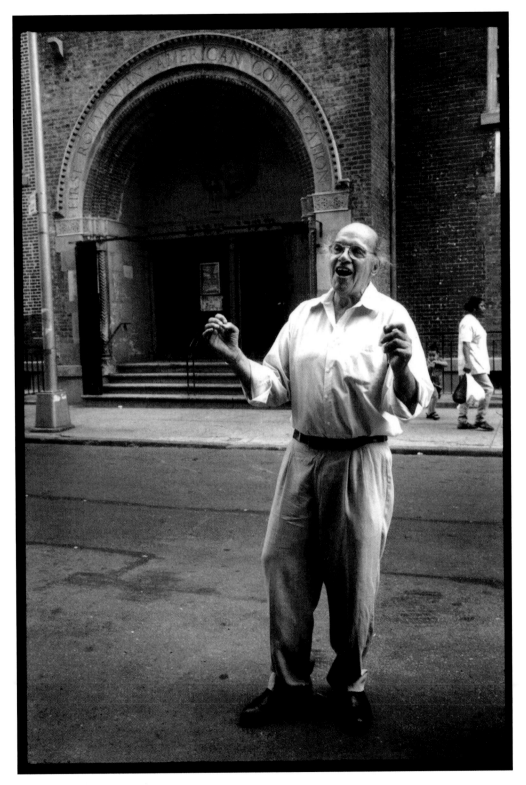

GERALD STERN
at the First Roumanian-American Congregation
Lower East Side, New York City, July 16, 1997

Daniel Jonah Goldhagen (b. 1959) has, on the strength of one book, become the world's most discussed scholar of the Holocaust. A political science professor at Harvard, Goldhagen is the author of *Hitler's Willing Executioners: Ordinary Germans and the Holocaust* (1996). Goldhagen's book shifts the focus of discussion away from abstract institutions and structures and places it on the human beings who committed the crimes, showing that many ordinary Germans, moved by anti-Semitism, willingly brutalized and killed Jews. Goldhagen's book was the number-one best-seller in many countries, including Germany and Austria, and has evoked a worldwide, often impassioned, discussion. Shortly after the book's German publication, Goldhagen toured Germany, presenting its conclusions and debating its critics. The public acclamation was such that the German media declared his trip a "triumphal procession." He was shortly thereafter awarded Germany's prestigious Democracy Prize.

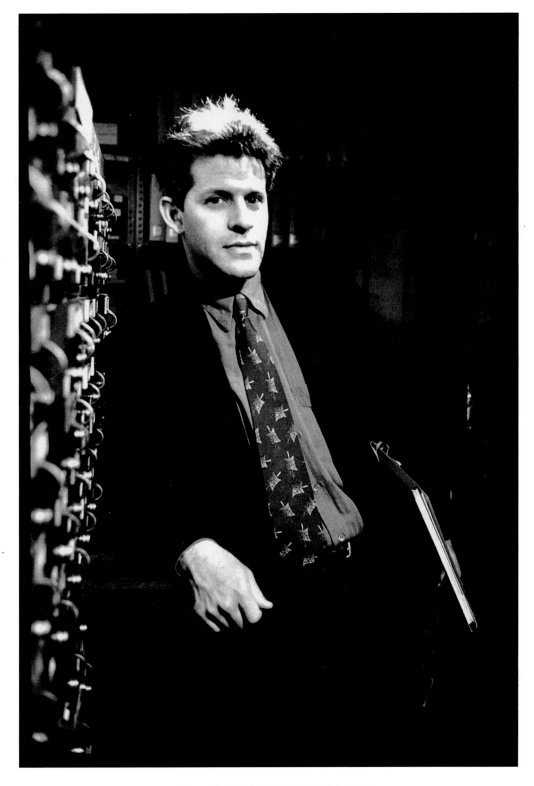

DANIEL JONAH GOLDHAGEN
next to the old wooden card catalogues, YIVO Institute for Jewish Research
New York City, January 23, 1998

Joseph Skibell's writing desk

Joseph Skibell (b. 1959) is a playwright and novelist. In his debut novel, *A Blessing on the Moon* (1997), Skibell reimagines the horrors of the Holocaust in a magical and macabre fable. The tale begins with the mass execution of all the Jews in a Polish village, followed by the disappearance of the moon. The village rabbi, in the form of a crow, asks the murdered merchant Chaim Skibelski (the author's great-grandfather) to relocate the missing moon. The result is a book of hope, transformation, remembrance, and renewal.

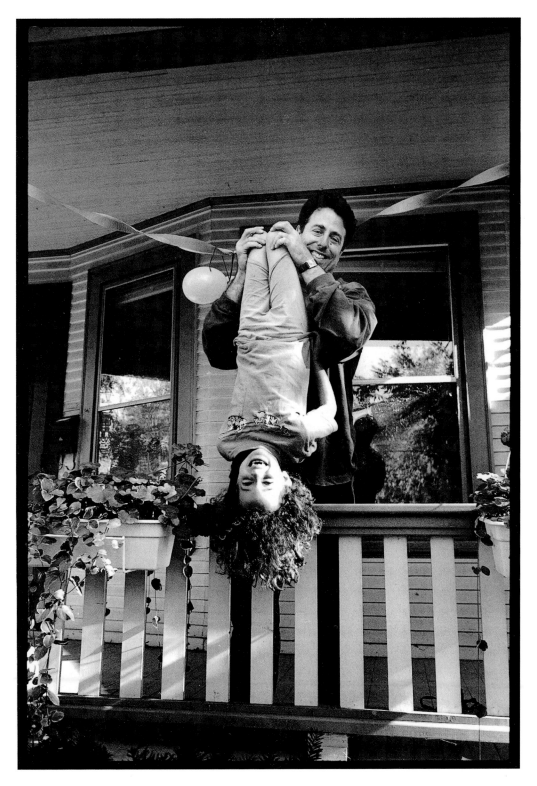

JOSEPH SKIBELL
with his daughter, Arianna, on her seventh birthday
Madison, Wisconsin, October 9, 1997

Marjorie tried to look annoyed; but she couldn't help it, she burst out laughing. They were riding around the park in a hansom cab on a frigid sunny March afternoon, their cheeks red and frostbitten, their hands warmly clinging under a huge mangy fur lap robe. Noel was hatless, and his hair was rumpled by the wind. He looked like a boy. His joy of life was infectious. One glance of his laughing brilliant blue eyes could make Marjorie as dizzy and happy as if she were on a roller coaster.

That was the day he persuaded her to eat a lobster.

from *Marjorie Morningstar*

Herman Wouk (b. 1915) subtly layered his Jewish faith and identity within the plots of early best-selling novels like *The Caine Mutiny* (1951), *Marjorie Morningstar* (1955), and *Youngblood Hawke* (1962), while also writing the nonfiction *This Is My God: The Jewish Way of Life* (1959). He has also written hugely successful historical novels about World War II and the Holocaust, *The Winds of War* (1971) and *War and Remembrance* (1978). *Inside, Outside* (1985) is the story of Israel David Goodkind, whose "inside" life of Jewish values and traditions struggles with his "outside" life of earning a living in America. In Mr. Wouk's latest historical novels, *The Hope* (1993) and *The Glory* (1994), the adventures of three Israeli military families encompass the country's wars during its first forty years. He is currently working with Jimmy Buffett on a musical version of his book *Don't Stop the Carnival* (1965), about Norman Paperman, a New York press agent who has a midlife crisis and buys a hotel in the Caribbean.

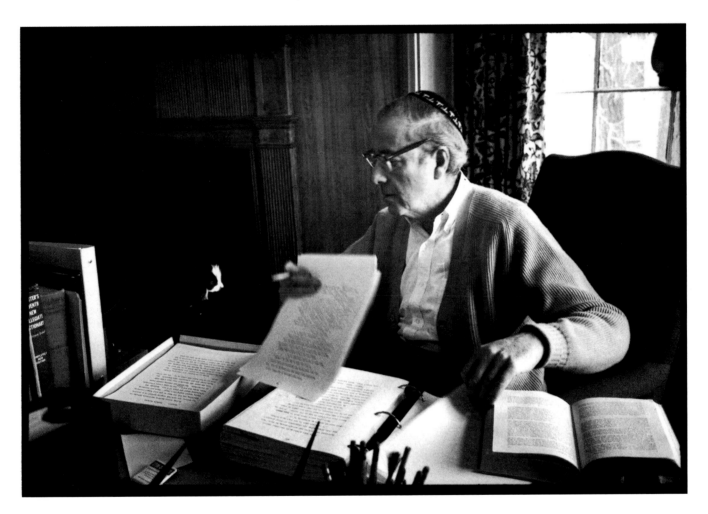

HERMAN WOUK
Washington, D.C., February 3, 1971

. . . My family was a rather typical socialist Jewish family. My father refused to go anywhere near a synagogue, although he allowed me to take my grandmother on holidays. On the other hand, we were clearly and peacefully Jewish, so there we were. . . .

I had a certain vanity about being Jewish. I thought it was really a great thing, and I thought this without any religious education. But I also really felt that to be Jewish was to be a socialist. . . .

I had this idea that Jews were supposed to be better. I'm not saying they were, but they were supposed to be; and it seemed to me on my block that they often were. I don't see any reason in being in this world actually if you can't in some way be better, repair it somehow. . . .

from *Just As I Thought*

Grace Paley (b. 1922), the daughter of Russian-Jewish immigrants, was raised "little Gracie Goodside" in the Bronx. Though she now lives most of the year in rural Vermont, she spent most of her life in New York City. A feminist, a pacifist, and a champion of numerous political causes, she has used her experiences, and a modern urban landscape, to write three volumes of honest, witty, and provocative stories—*The Little Disturbances of Man* (1959), *Enormous Changes at the Last Minute* (1974), and *Later the Same Day* (1985), as well as two volumes of poetry and a collection of old and new pieces, *Long Walks and Intimate Talk* (1991). Her most recent book, *Just As I Thought* (1998), combines thirty years of Paley's autobiographical essays and political reporting with irreverent updates from this funny, feisty, and beloved "elder" of us all. Addressing the issue of growing older, Paley writes: "You may begin to notice that you're invisible. Especially if you're short and gray-haired. But I say, to whom? And so what! On the other hand, people do expect wise and useful remarks— so naturally, you offer them. This is called the wisdom of the old."

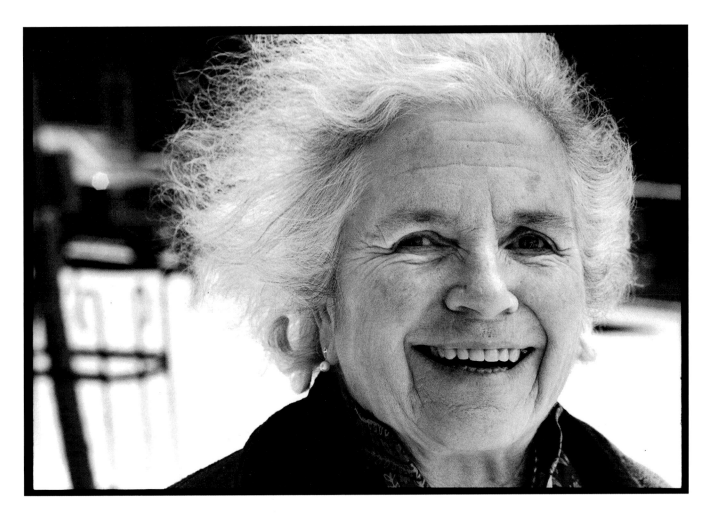

GRACE PALEY
New York City, May 21, 1997

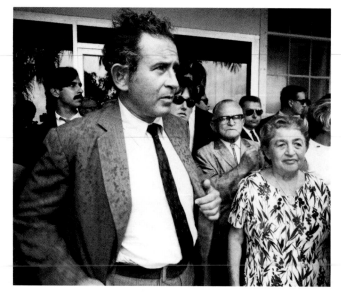

Norman Mailer with his parents
Miami International Airport, August 1968

10 October, 1985

Dear Jill,

What a fine memory you have. You brought back to me the day we were at the airport, I to meet my parents and you to take the picture of Rockefeller as he came into the convention. How excited my mother was that her plane and his landed within a few minutes of each other. You reminded me that she went up to him and told him that she knew he was going to win the nomination. Even at the time, I remember thinking, "Gee Mom, and I always supposed you had a lot of common sense!"

Well, cheers to your memory. (Your working memory that is.)

Love,
Norman

Norman Mailer (b. 1923) has never been one to resist a literary challenge, and his most recent novel, *The Gospel According to the Son* (1997), may be his boldest to date. In it, he recasts the life of Christ—"the renegade Jew, the one who brought all the trouble down on the Jews"—as a first-person narrative. Always controversial, Mailer is, in the words of Alfred Kazin, "a born novelist of society, so fascinated by its corruption and violence that he seems propelled to imitate its every appetite and to ride its roller coaster." He boarded that roller coaster with his first novel, *The Naked and the Dead* (1948), riding through five decades with such important works as *The Armies of the Night* (1969), *The Executioner's Song* (1979), and *Harlot's Ghost* (1991). In a recent interview with *The New York Times*, Mailer suggests a career spent in pursuit of a plausible God. "What people don't understand," he says, "is that religion has been a major theme in all of my work."

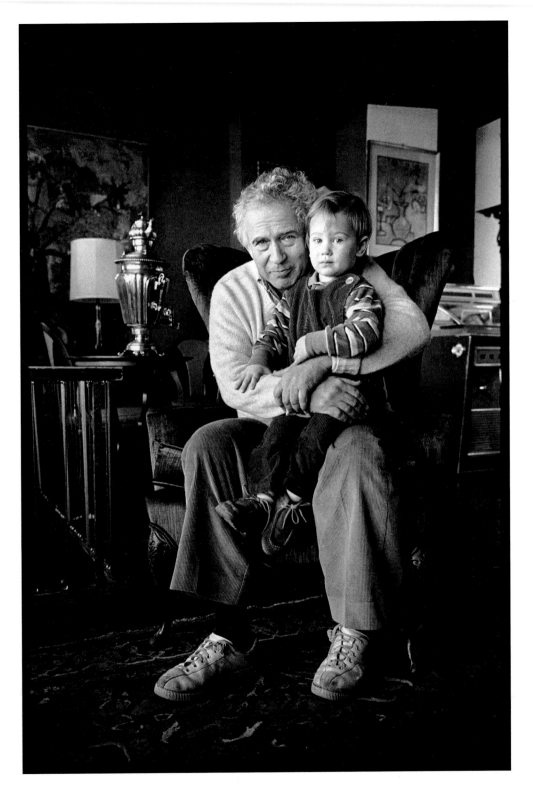

NORMAN MAILER
with his son, John Buffalo
Brooklyn Heights, New York, February 5, 1980

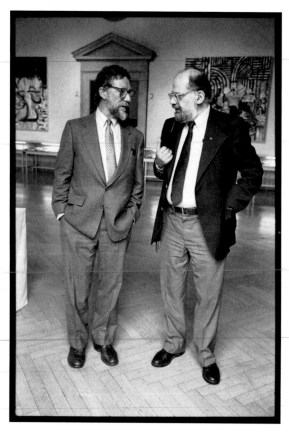

**Gary Snyder and Allen Ginsberg at the
American Academy of Arts and Letters
New York City, May 18, 1988**

Allen Ginsberg (1926–1997) was, at his all too sudden death,
the most recognizable American poet in the world. He described
his verse as "Hebraic-Melvillian bardic breath" and declared
on numerous occasions—once to the anti-Semitic poet Ezra
Pound—"I am a Buddhist Jew." Best known for his revolutionary
Howl (1956), Ginsberg paid homage to his mother, and their
Jewish heritage, in *Kaddish* (1961). His *Selected Poems* (1996)
was published to coincide with the thirtieth anniversary of the
St. Marks Poetry Project, which he cofounded. Ginsberg took
an active and impassioned part in the shaping of his times.

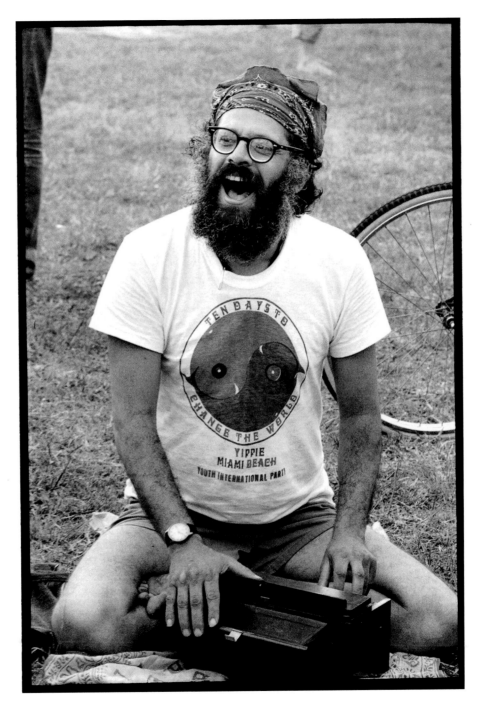

ALLEN GINSBERG
at the Democratic National Convention
Flamingo Park, Miami Beach, Florida, July 9, 1972

"Tommy"
An illustration from Al Hirschfeld's
Manhattan Oases: New York's 1932
Speak-Easies

Until Lionel and I decided to marry, we were
never wholly sober in each other's company. . . .
At Mario's, Lionel's and my favorite drink was
something called a Bullfrog, made of gin, apricot
brandy, and grenadine. We alternated our
Bullfrogs with Alexanders; these were, I think,
made of brandy, crème de cacao, and heavy
cream. Alexanders were liquid desserts but we
drank them not only before dinner but through
long evenings of conversation.

—Diana Trilling
from *The Beginning of the Journey*

Lionel (1905-1975) and Diana (1905-1996) Trilling were an
extraordinary pair, a marriage of intellectual equals at the heart
of New York's literary life. He was an eminent professor, lecturer,
critic, novelist, and author of classic works *The Middle of the
Journey* (1947), *The Liberal Imagination* (1950), and *Beyond Culture*
(1965). The first Jewish professor in the English Department of
Columbia University to be appointed a member of the faculty,
Lionel Trilling was, according to David Denby, "the greatest of
the New York intellectuals." Diana Trilling was a cultural critic,
biographer, and essayist. Her books *Claremont Essays* (1964) and
We Must March My Darlings (1977) reflect her legendarily high
standards and biting wit. Her memoir, *The Beginning of the Journey:
The Marriage of Diana and Lionel Trilling* (1993), is a narrative of their
lives, both probing and personal. They were both twenty-one when
they met at a speakeasy called Mario's. Their marriage lasted for
forty-six years, until Lionel's death in 1975.

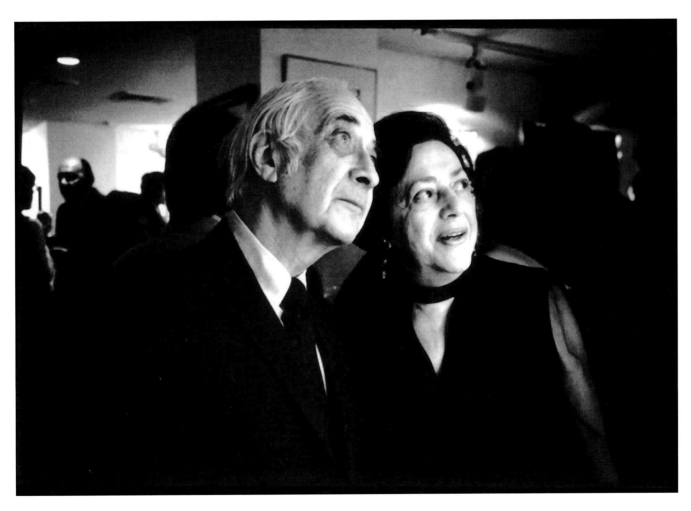

LIONEL AND DIANA TRILLING
New York City, May 7, 1974

Philip Roth (b. 1933) is a Jewish-American original, a prolific writer who possesses one of the world's most challenging, distinctive, and controversial literary voices. In *Goodbye, Columbus* (1959), *Portnoy's Complaint* (1969), *Operation Shylock* (1993), *Sabbath's Theater* (1995), and the extraordinary *American Pastoral* (1997), he has written about American Jews and Jewish history with vigorous realism, grappling with issues of sexuality, self-hatred, ambition, assimilation, and the shattering of the American dream. Fiercely intellectual, his work continues to challenge narrative form while exploring, not without humor, his uniquely virile landscape. In his essay "Imagining Jews," Roth writes, "The task for the Jewish novelist has not been to go forth to forge in the smithy of his soul the *un*created conscience of his race, but to find inspiration in a conscience that has been created and undone a hundred times over in this century alone."

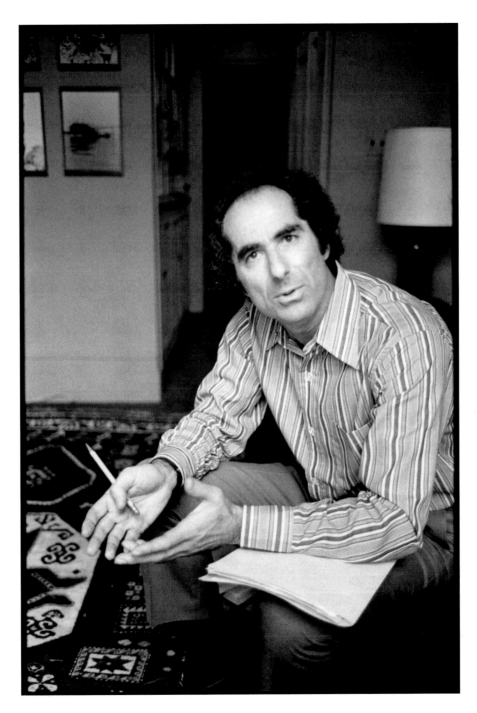

PHILIP ROTH
New York City, September 6, 1972

Tillie Olsen (b. 1913) grew up in the Midwest, the daughter of working-class Jewish immigrants who were active in the labor movement. Coming of age in the Depression, she became a labor unionist and, by 1934, had been jailed three times for her activities. These experiences inspired her to write, resulting in the novel *Yonnondio: From the Thirties,* which was started in 1934 but not published until 1974. Between these years, she raised a family and worked hourly wage jobs, only returning to her writing in the late 1950s, when she was awarded a grant that allowed her to complete the stories in her best-known book, *Tell Me a Riddle* (1961). The title tale is about a Jewish woman who wants to break out after a lifetime of caring for others to experience life and death on her own. *Silences* (1978) addresses those voices muted by economic necessity, race, class, and religious prejudice.

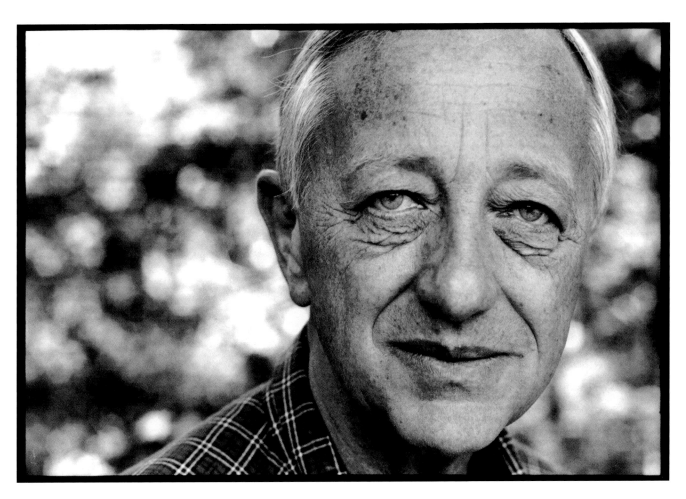

LOUIS BEGLEY
Sagaponack, New York, July 20, 1997

Philip Rahv (b. Greenberg, 1910–1973) was born in a small village in White Russia, and emigrated to America when he was fourteen. Though he never graduated from high school, he went on to become an important literary critic and the founder of the *Partisan Review*. His essays on Chekhov, Tolstoy, and Dostoevsky, as well as theoretical essays on American literature such as "Paleface and Redskin," are considered classics. He was feared but revered by his fellow New York intellectuals and by a younger generation of students and writers.

Alan Lelchuk (b. 1938) met Philip Rahv on the Brandeis University faculty in 1966. They became good friends, and in 1970, Lelchuk joined Rahv's new cultural quarterly, *Modern Occasions*, as associate editor. Rahv was a strong influence on Lelchuk's first politically explosive novel, *American Mischief* (1973). Lelchuk's novels since then have included *Miriam at Thirty-four* (1974), *Miriam in Her Forties* (1985), and *Brooklyn Boy* (1990).

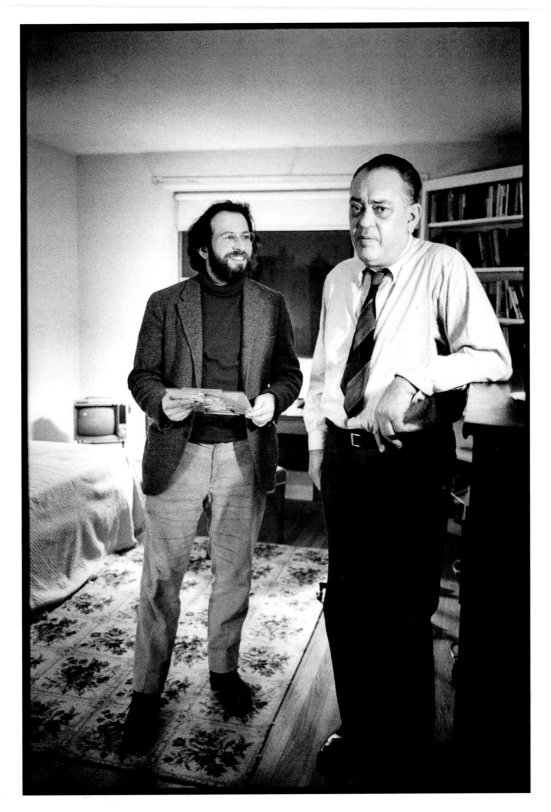

ALAN LELCHUK AND PHILIP RAHV
Cambridge, Massachusetts, November 29, 1972

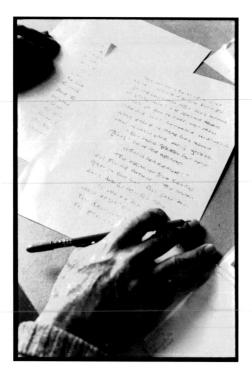

**Bernard Malamud working on his
short story "God's Wrath"**

The next day he tried to find her. Where do you look for your daughter who has become a prostitute? He waited a week for her to call, but when she did not he called information and asked if there has been a new number for a Lucie Glasser.

"Not Lucie Glasser but Lucie Glass," said the operator.

"What is her address?"

The operator gave her one on Third Avenue. The sexton put on his hat, his fall coat, and he took his cane.

from the manuscript page of "God's Wrath"

The next morning he woke in the dark and determined to find her. But where do you look for a daughter who has become a whore? He waited a few days for her to call, and when she didn't, on Helen's advice he dialed information and asked if there was a new telephone number in the name of Luci Glasser.

"Not for Luci Glasser but for Luci Glass," said the operator.

"Give me this number."

The operator, at his impassioned insistence, gave him an address as well, a place on midtown Ninth Avenue. Though it was still September and not cold, the sexton put on his winter coat and took his rubber-tipped heavy cane.

The same passage as it appeared in the published book

Bernard Malamud (1914–1986) grew up in a poor Brooklyn neighborhood, the son of a Jewish grocer not unlike his fictional Morris Bober in *The Assistant* (1957), a novel that explores the twin themes of redemption and virtuous suffering. Using the cadence of Yiddish and what Philip Roth has called his "lineaments of moral allegory," Malamud quietly but forcefully pursued these same themes in other books of fiction such as *The Natural* (1952), *The Assistant* (1957), *The Magic Barrel* (1959), *The Fixer* (1967), and *The Tenants* (1971), as well as the recently assembled *The Complete Stories of Bernard Malamud* (1997). He once described his characters as "simple people struggling to make their lives better in a world of bad luck" and his influences as "Chekhov, James Joyce, Hemingway, Sherwood Anderson, and a touch perhaps of Sholem Aleichem and the films of Charlie Chaplin."

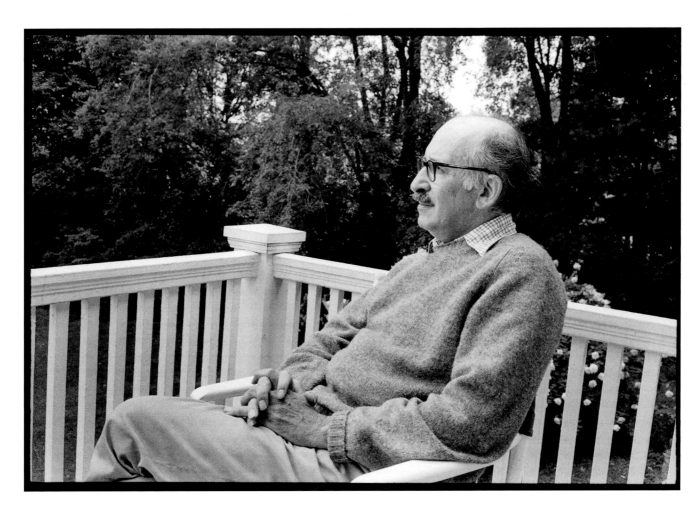

BERNARD MALAMUD
Bennington, Vermont, August 24, 1971

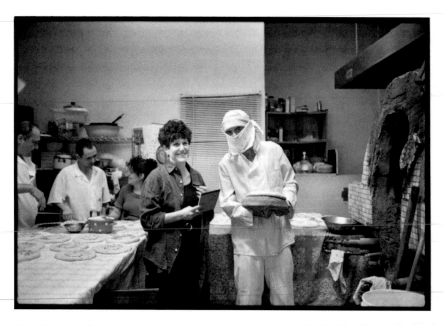

The baker's face is covered to protect it from the open oven's intense heat.

Joan Nathan (b. 1943) uses food as a way of telling the story of the Jewish people. She has made the Jewish kitchen her literary home, chronicling and celebrating Jewish cuisine from the Casbah, concentration camps, the kibbutz, and the Caucasus during this century's Diaspora. Born in Providence, Rhode Island, Nathan moved to Jerusalem after college to work for Mayor Teddy Kollek. Over the next three years, she freely sampled the diverse foods of Ashkenazic, Sephardic, and Oriental Jews. "With Jews from seventy different countries living in Israel," she has written, "Jerusalem seemed to me the epicenter of Jewish cuisine." Her books include *The Jewish Holiday Kitchen* (1979), *Jewish Cooking in America* (1994), and *The Jewish Holiday Baker* (1997).

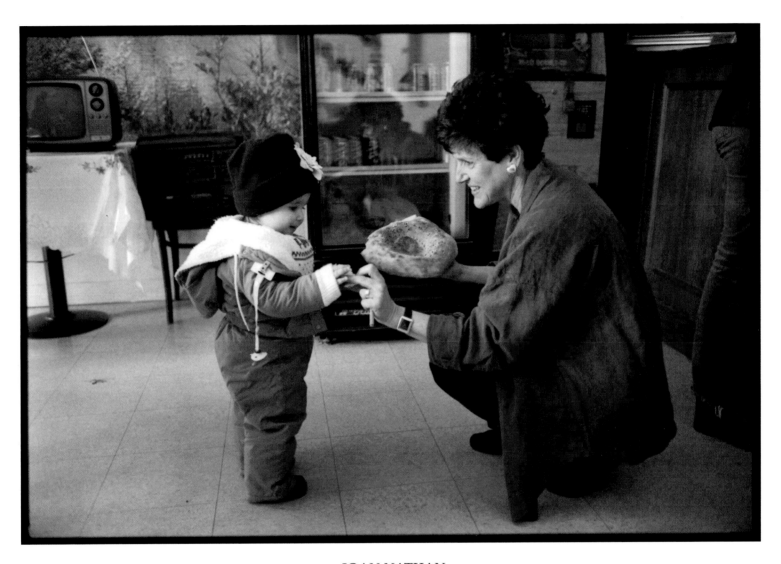

JOAN NATHAN
at a kosher Uzbek bakery with a very young taster,
Sabrina Yulchevsky, the granddaughter of the bakery owner
Kew Gardens, New York, February 16, 1998

Aryeh Lev Stollman (b. 1954) has published a debut novel, *The Far Euphrates* (1997), that traces the coming of age of a rabbi's ruminative son in Windsor, Ontario, as he confronts the collective memory of his tight-knit Jewish circle and his own double-edged quest for freedom. It ends on an elegiac note, at his father's funeral: "When I said the prayers at the graveside, I spoke in the language of earliest times. I said all the words, with their constellations of letters that had once combined themselves this way and that in myriad forms to create all of our souls and to create this world, which is our home." The son of a rabbi, Dr. Stollman is also an interventional neuroradiologist.

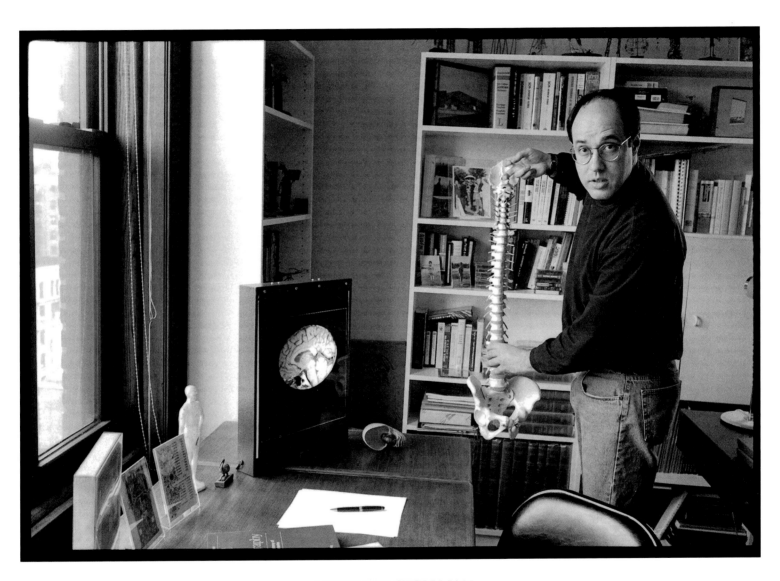

ARYEH LEV STOLLMAN
New York City, May 29, 1997

All Hebrew School led up to the Bar Mitzvah and the singing of the Haftarah. Stern, who had a good voice, took to trilling occasional high notes in his practice rendition, and the Haftarah coach would say: "No crooning." On the day of his Bar Mitzvah, Stern sang it flawlessly, and his mother, afterward, said: "You had some voice. I could have fainted."

"Yes," said the Haftarah coach, "but there was too much crooning."

from *Stern*

Bruce Jay Friedman (b. 1930) has established himself as one of America's preeminent "black humorists," which is only to say that he is, in the tradition of Gogol and Babel, both deadly serious and painfully funny. Friedman delivered the literary equivalent of a first-round knockout with *Stern* (1962), which traced the fall and rise of a decent but bedeviled man raised in a traditional Jewish-American home but determined to assimilate in suburbia. In this and his other novels, which include *A Mother's Kisses* (1964), *About Harry Towns* (1974), and *The Current Climate* (1989), Friedman conflated the classic Jewish *schlemiel* story with a withering portrait of American values. When asked to define the term *black humor*, which he coined to describe his and other brash young satirists' work, Friedman replied, "I would have more luck defining an elbow or a corned beef sandwich."

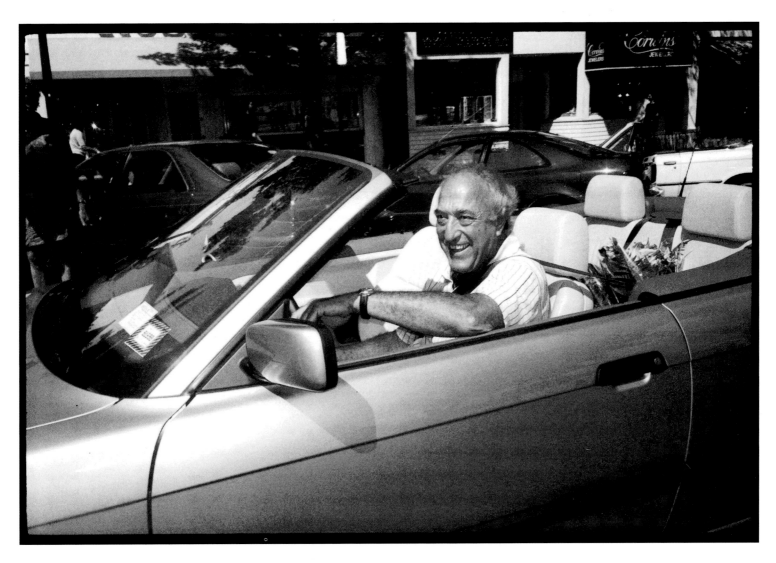

BRUCE JAY FRIEDMAN
Southampton, New York, August 23, 1997

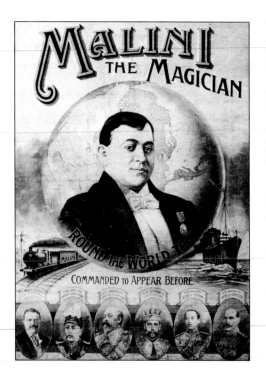

**Lithograph used to advertise
Malini's appearance at
King's Theater in New York**

In California, I sat for hours beguiled
by Ozzie Malini, son of Max Malini,
the remarkable magician. "Did you
hear what my father did to Mayor
Brown of the Philippines?" he asked.
"At an elaborate state dinner the
mayor and guests tried to play a joke
on my dad. Knowing he was Jewish,
they decided to serve him a roast pig—
complete with an apple in its mouth.
Undaunted, my father covered the
platter with his napkin and stared at
the company. When he whisked the
napkin away, the pig had vanished and
a cooked chicken occupied its place."

from *Learned Pigs & Fireproof Women*

Ricky Jay (b. circa 1947) is a performer of sleight of hand who
has been heralded as one of our most singular entertainers.
His whimsical style and subject matter belie his seriousness as a
scholar. As a writer and historian Jay has concentrated on unusual
entertainers of the past. He chronicles the exploits—and continues
in the tradition—of Jewish magicians such as Houdini, Horace
Goldin, Nate Leipzig, and especially Max Malini, whom he
features in his book, *Learned Pigs & Fireproof Women* (1986).
His contribution to the Writers and Artists Series at the Whitney
Museum resulted in *The Magic Magic Book,* a dissertation on the
oldest conjuring books ever published. Jay's emphasis on the
varia and ephemera of his arcane world is exemplified in his
ongoing fine press quarterly, *Jay's Journal of Anomalies.*

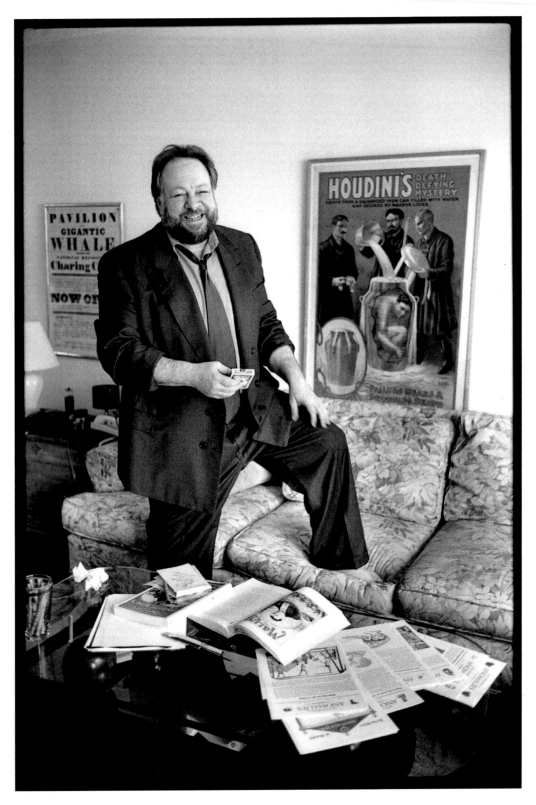

RICKY JAY
New York City, January 26, 1998

Amos Oz (b. 1939) is a sabra, or native-born Israeli, who fought in his nation's many armed conflicts and lived most of his adult life at Kibbutz Hulda, a large collective community. His essays and fiction are required reading for anyone who wishes to understand the hopes, dreams, and nightmares driving the realities of life in the modern Israeli state. A deeply compassionate individual, he is committed to the collective ideals and goals of his nation, describing the ironies, tensions, and fears that propel his country as well as his writings, which include the novels *My Michael* (1968), *Black Box* (1988), and *Fima* (1993). He has also written a national portrait, *In the Land of Israel* (1983), and edited *Until Daybreak: Stories from the Kibbutz* (1984). His most recent novel, *Panther in the Basement* (1997), is about an Israeli looking back to the summer of 1947.

AMOS OZ
New York City, November 21, 1983

Wendy Wasserstein (b. 1950) is a playwright whose work is both wildly funny and poignantly truthful. She brilliantly depicts the humorous, often traumatic tensions within the Jewish family as well as the painful struggles of independent, successful young women living with their own powerful longing for family and tradition. Her plays include *Uncommon Women and Others* (1975), *Isn't It Romantic?* (1984), *The Heidi Chronicles* (1988), *The Sisters Rosensweig* (1993), and *An American Daughter* (1997). "Funny is a very complicated issue," she says.

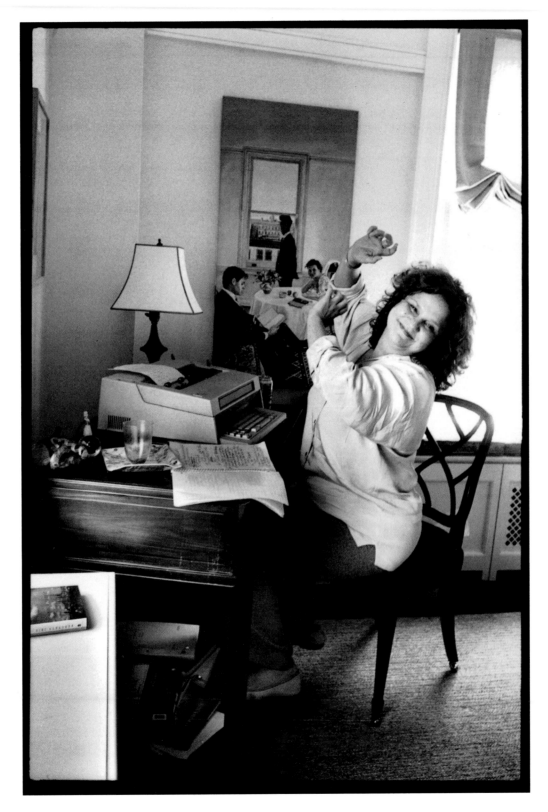

WENDY WASSERSTEIN
New York City, July 14, 1997

Then, very gradually, these other creatures began to emerge on my drawing paper, and I knew right away that they were my uncles and aunts. They pinched us and poked us and said those tedious, boring things that grown-ups say, and my sister and my brother and I sat there in total agony and rage. The only fun we had was later, giggling over their grotesque faces—the spiraling hair pouring out of their huge noses. So I know who those "wild things" are. They are my Jewish relatives. I did eventually learn to love them.

Maurice Sendak (b. 1928) has for more than forty years challenged established ideas about what children's literature is and should be with the books he has written and illustrated. The youngest son of immigrants from a *shtetl* just outside Warsaw, Sendak grew up in Brooklyn. In his collaboration with Isaac Bashevis Singer, illustrating *Zlateh the Goat* (1966), a particular pleasure for him was hearing Singer read his stories in the original Yiddish, the language spoken in Sendak's childhood home. He readily admits that such passions and influences from his own life—Mozart, Melville, opera, the Holocaust, his annoying relatives, and his childhood hatred of school and bouts of pneumonia—all creep into his books, whether in fine details of illustration or in the primary fears of his characters. Sendak's much loved works include *Dear Mili* (1988), an incomparable interpretation of the newly discovered tale by Wilhelm Grimm, *Chicken Soup with Rice* (1962), and *Where the Wild Things Are* (1963), one of the great children's classics.

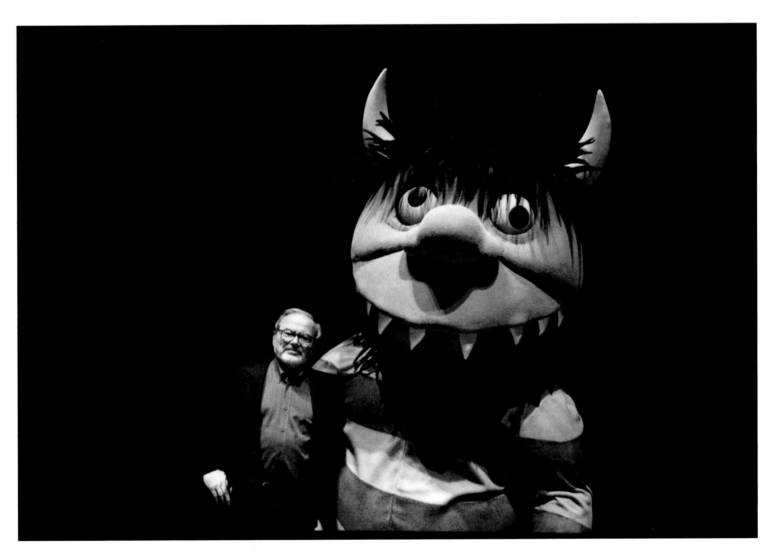

MAURICE SENDAK
on his set for American Repertory Ballet's *Where the Wild Things Are*
New Brunswick, New Jersey, February 20, 1998

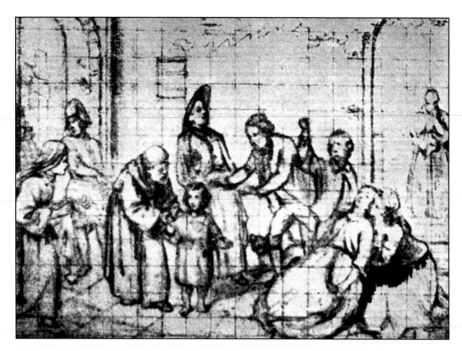

My husband and I made our way to the Catechumens. . . . We went in and soon we had our beloved Edgardo in our arms. Sobbing and weeping, I kissed him and kept kissing him, and with great affection he returned our kisses and our hugs. He blushed deep red with emotion and cried, struggling between the fear he had for the man who controls him and his unchanged affection for his parents. . . . I told him that he was born a Jew like us and like us he must always remain one, and he replied: 'Si, mia cara mamma, I will never forget to say the Shema every day.' When I told him that we had come to Rome to get him back, and that we'd not leave without him, the greatest joy and happiness came over him!

from *The Kidnapping of Edgardo Mortara* (from a letter of Marianna Mortara to a friend in Bologna, on first seeing her son four months after he was taken to a church institution for the conversion of the Jews in Rome, 1858)

The Kidnapping of Edgardo Mortara, 1858: **A Drawing by Moritz Oppenheim**
Depiction of the taking of six-year-old Edgardo by priests and police,
as his mother faints and his father protests

David I. Kertzer (b. 1948) is an anthropologist and historian. The topics addressed in his books seem at first glance incredibly diverse. He began by spending a year in a poor neighborhood in Bologna and writing a book, *Comrades and Christians* (1980), about the fierce struggle between the Italian Communist Party and the Catholic Church. He then wrote various books about family life in the European past, including *Sacrificed for Honor* (1993), a chilling account of the huge number of newborn babies who used to be left at foundling homes, and the mothers who left them there. His most recent book, *The Kidnapping of Edgardo Mortara* (1997), is the wrenching story of a small Jewish boy in Bologna, Italy, who was taken from his family in 1858 on orders of the Inquisitor because he had been secretly baptised by a teenage servant. As Kertzer movingly recalls in the book's afterword, his fascination with the case of the little Italian Jewish boy, and the international storm it triggered, has its roots in the stories he heard as a small child about his father's experiences as a Jewish chaplain in the American army units that liberated Rome from the Nazis.

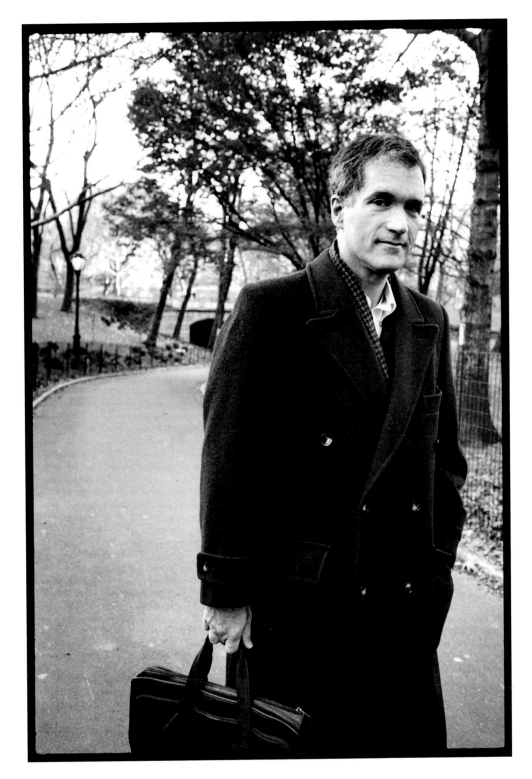

DAVID I. KERTZER
New York City, December 3, 1997

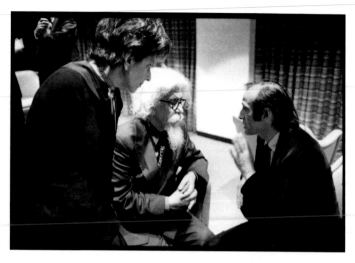

**Elie Wiesel with Sylvia and Abraham Joshua Heschel
New York City, February 24, 1972**

I made friends with the Yiddish poet and thinker from Warsaw, Abraham Joshua Heschel, the great-grandson of the Rebbe of Apt. Heschel was profoundly Jewish, a deep believer and a sincere pacifist who wrote lyric poems in Yiddish.

Heschel was the major spokesman for Jewish ecumenism, a Jewish friend of all the oppressed. He was among the first to fight for Russian Jews and—it should be noted—for American blacks. It was he who introduced me to Martin Luther King, Jr., whom he revered. In the civil rights movement they called him Father Abraham, as a result of which certain Orthodox circles kept their distance from him, which caused him grief. "He's too close to the Christians," they said. Nonsense, I replied when I heard such criticism. What is wrong with a Jew teaching Judaism to non-Jews while defending the honor and tradition of his people?

from All Rivers Run to the Sea

Elie Wiesel (b. 1928) won the 1986 Nobel Peace Prize for his message "of peace, atonement and human dignity." Born in Romania, he and his family were taken to Auschwitz, then Buchenwald, where he was liberated in 1945, at age sixteen. He has used the darkness of that time—what he calls "the kingdom of night"—and the near destruction of the Jewish people to produce moving documents such as *Night* (1960) and novels such as *A Beggar in Jerusalem* (1970), *The Testament* (1981), and *The Forgotten* (1992). In the first volume of his memoirs, *All Rivers Run to the Sea* (1995), Wiesel begins: "If there is a single theme that dominates all my writings, all my obsessions, it is that of memory—because I fear forgetfulness as much as hatred and death."

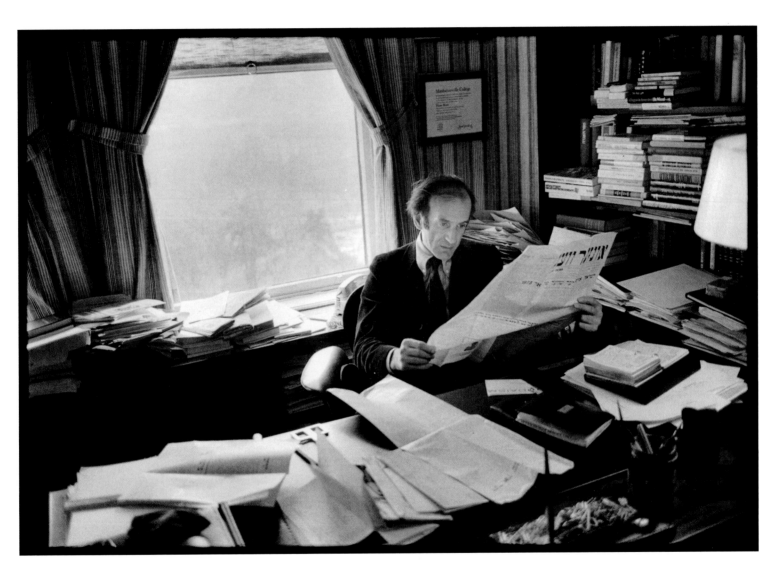

ELIE WIESEL
New York City, February 14, 1973

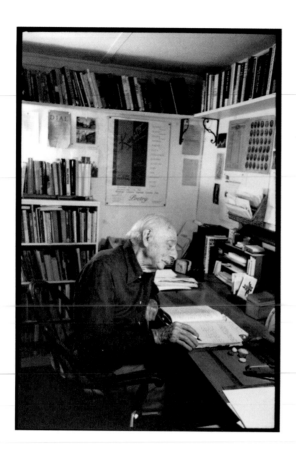

AN OLD CRACKED TUNE

My name is Solomon Levi,
the desert is my home,
my mother's breast was thorny,
and father I had none.

The sands whispered, Be separate,
the stones taught me, Be hard.
I dance, for the joy of surviving,
on the edge of the road.

from *Passing Through*

Stanley Kunitz (b. 1905) has sustained an astonishingly high level of artistry and passion in his work from his landmark *Selected Poems* (1958) to his most recent collection, *Passing Through* (1995). Kunitz was born and raised in Worcester, Massachusetts, where his parents ran a dress-manufacturing business. Only a few weeks before Stanley's birth, his father committed suicide. His mother, descended from Sephardic Jews and raised in Lithuania, took over the business after it went bankrupt and made it a success. She was, he writes, "a woman of formidable will, staunch heart, and razor-sharp intelligence, whose only school was the sweatshops of New York." In a speech at the 92nd Street Poetry Center celebrating his ninetieth birthday, Kunitz remarked, "We belong less to what flatters us than to what scars."

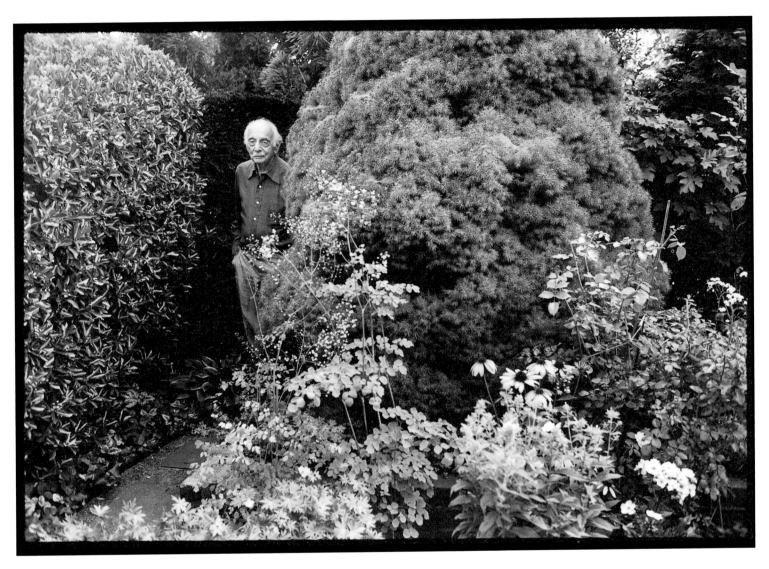

STANLEY KUNITZ
in his garden
Provincetown, Massachusetts, August 6, 1996

We lived on the top floor of a five-story tenement in Williamsburg, facing the BMT elevated train, or as everyone called it, the El. Our floors and windows would vibrate from the El, which shook the house like a giant, roaring as his eyes were being poked out. When we went down into the street we played on a checkerboard of sunspots and shadows, which rhymed the railroad ties above our heads. Even the brightest summer day could not lift the darkness and burnt-rubber smell of our street. I would hold my breath when I passed under the El's long shadow. It was the spinal column of my childhood, both oppressor and liberator, the monster who had taken away all our daylight, but on whose back alone one could ride out of the neighborhood into the big broad world.

from *Bachelorhood*

Phillip Lopate (b. 1943) grew up in the Jewish section of Williamsburg when it was a neighborhood shared by secular Jews like his family and the Satmars, a secluded Hasidic group who now predominate in the area. Lopate is a writer of wide interests and many talents, a poet, novelist, film critic, schoolteacher, professor, and, most prominently, an essayist. Editor of the anthology *The Art of the Personal Essay* (1994), he has also published three of his own collections, *Bachelorhood* (1981), *Against Joie de Vivre* (1990), and *Portrait of My Body* (1996). In the latter, Lopate confesses to "being a secular, fallen Jew with a taste for rationalism and history," and in a controversial but brutally honest essay, "Resistance to the Holocaust," he examines what it means to be Jewish in modern America.

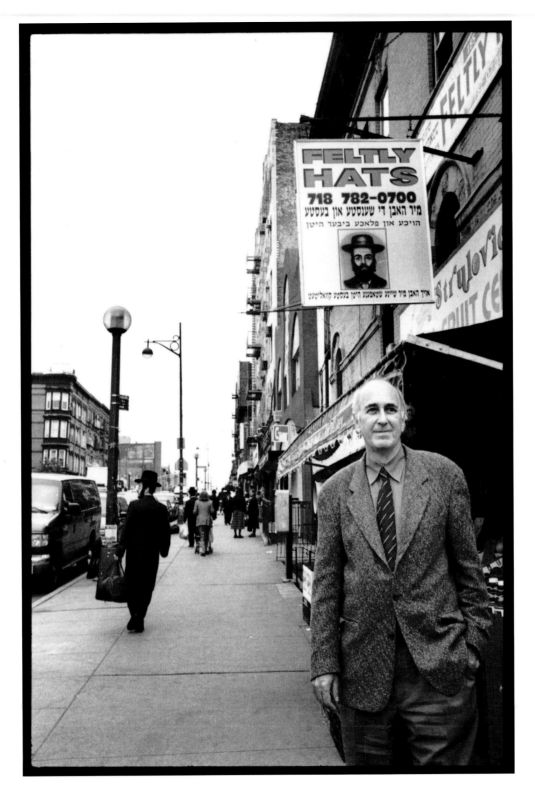

PHILLIP LOPATE
on the streets of Williamsburg
Brooklyn, New York, May 1, 1998

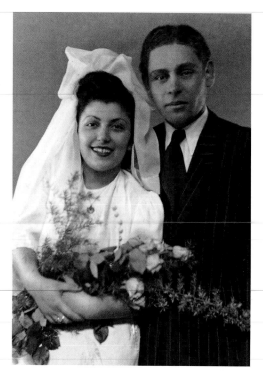

My parents, Phillip and Fay Sucher, Polish Jewish survivors of the Holocaust, were married in October 1947 in Lübeck, Germany, in a lavish double wedding ceremony alongside my Uncle Sam and Tante Lonke, who were too poor to pay for their own nuptials. My father was the event's impresario—employing the rabbi, hiring the photographer, sending out the engraved invitations and even arranging for the rental of my mother's satin wedding dress and veil. Though it was only two years after the liberation and luxury goods were in short supply, my father was a keen wheeler-dealer known for his ability to get anything from pineapples to diamonds on the black market. Marrying my mother, whom he always referred to as "the prettiest girl in all of Lübeck," was the happiest moment in his life. As there was no photographic record of my parents' lives before the war, this portrait always represented for me the promise and hope of renewal offered by true love, even after the devastation of the Holocaust.

Cheryl Pearl Sucher (b. 1957) is a new novelist whose writing reflects Jewish traditions and concerns through a prism of modern American society. A daughter of Holocaust survivors, Sucher has, in her remarkable debut, *The Rescue of Memory* (1997), dramatized a family's dark past, her fictional Rachel torn between a rabbi's warning to "never forget" and her own need for independence. Raised in a household where Yiddish was the language of history and laughter, Sucher has dedicated her work to re-creating the heartbreak, humor, and compassion that is her legacy.

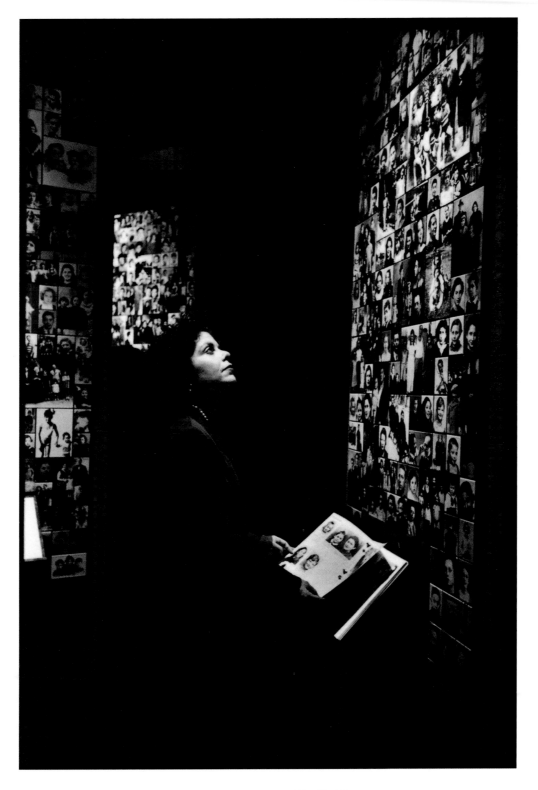

CHERYL PEARL SUCHER
at the Museum of Jewish Heritage
New York City, December 21, 1997

As a Jew, I'm connected to many places. . . .
If you're Jewish, you're also Everyman.
Look at the Bible. It's the story about one
particular, obscure Semitic tribe, but it has
universal human appeal.

Aharon Appelfeld (b. 1932) survived an unsurpassably grim
childhood. Born in Czernovitz, Bukovina (now part of Ukraine),
of Polish parents, Appelfeld was nine years old when his mother
was killed by Nazi troops. He and his father were sent to a labor
camp, from which he escaped, wandering in the forests for two
years, "afraid to speak to anyone." After the war, he joined the
Soviet army as a kitchen boy, eventually emigrating to Palestine.
There he was reunited with his father in 1960. These experiences
form the core of his remarkable body of work, a gripping series
of novels that includes *Badenheim, 1939* (1980), *Tzili* (1983),
The Retreat (1984), *To the Land of the Cattails* (1986), and *For Every
Sin* (1989). His most recent book, *The Iron Tracks* (1998), has been
hailed worldwide as his masterpiece.

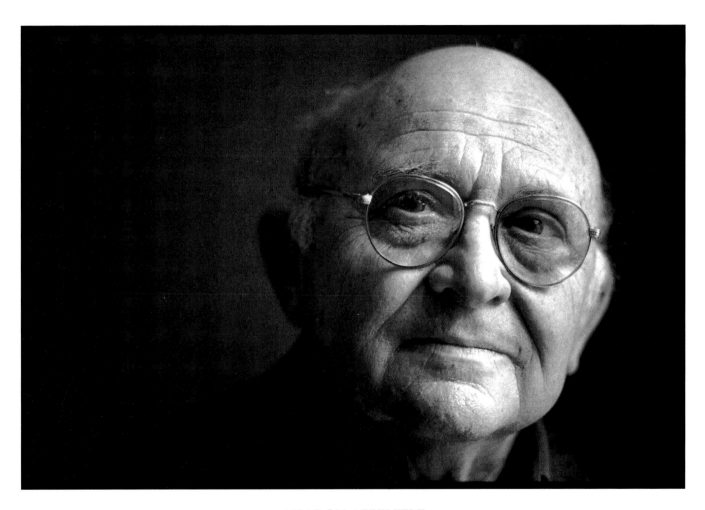

AHARON APPELFELD
New York City, March 27, 1998

Hebrew- and Yiddish-illiterate, I barely know
how to pray; riddled with ambivalence, child of
Marx, Freud, Mahler, Benjamin, Kafka, Goldman,
Luxemburg, Trotsky, Ansky, Schoenberg, mongrel
product of Judaism's (and of Jewish) exteriority,
of its ghetto-hungry curiosity, of its assimilationist
genius, I now approach Judaism as Jews once
approached the splendid strangeness of the
Goyische Welt: deeply confused, not complacent.
And this I think of course is profoundly Jewish.

Tony Kushner (b. 1956), who still considers himself a novice,
is amazed to discover that he is now forty-one years old
and that he has been writing plays for fifteen years.
Among these are *A Bright Room Called Day* (1984); *Angels in
America* (*Millennium Approaches*, 1990; *Perestroika*, 1992); *Slavs!
or Thinking About the Long-standing Problems of Virtue and
Happiness* (1994); his adaptation of S. Ansky's Yiddish classic,
A Dybbuk (1995); and the forthcoming *Henry Box Brown, or
The Mirror of Slavery.* He is torn between two yearnings:
to become a Jew-in-the-Library, one of those smart *buchers*
who've read everything, or a Jew-in-the-Streets, eternally
outraged that the world is void of righteousness, determined
to fix it! And then there's the great Jewish theatrical mandate,
"A little song, a little dance, a little seltzer down your pants."

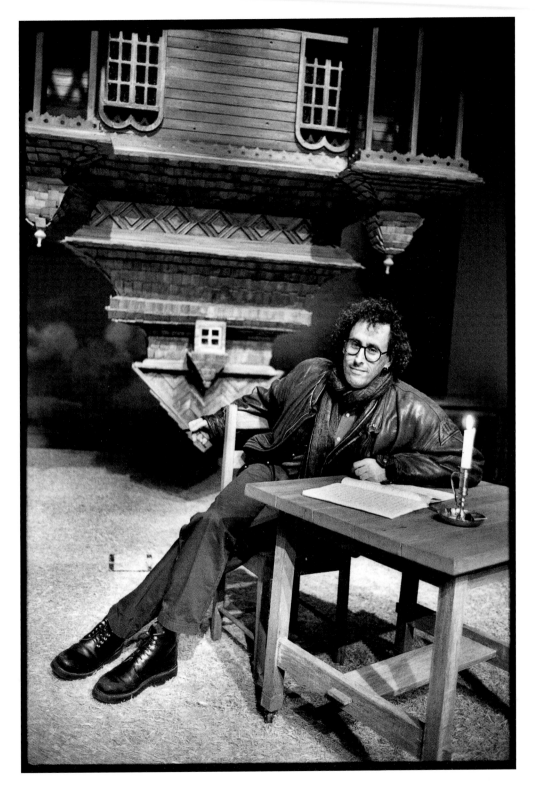

TONY KUSHNER
on the set of *A Dybbuk* at the Joseph Papp Public Theater
New York City, November 30, 1997

At the peak of its development the *shtetl* was a highly formalized society. It had to be. Living in the shadow of lawlessness, it felt a need to mold its life into lawfulness. It survived by the disciplines of ritual. The 613 *mitzvot,* or commandments, that a pious Jew must obey, which dictate such things as the precise way in which a chicken is to be slaughtered; the singsong in which the Talmud is to be read; the kinds of food to serve during the Sabbath; the way in which shoes should be put on each morning; the shattering of a glass by the groom during a marriage ceremony—these were the outer signs of an inner discipline.

from *World of Our Fathers*

Irving Howe (1920–1993) was at the center of American intellectual life for half a century as a literary critic, editor of the leftist journal *Dissent,* writer for *Partisan Review,* historian, and distinguished professor of English. Among the wide array of books with which he is associated, Howe helped edit collections of Yiddish literature as well as *The Essence of Judaism* (1948). His best-known work was the historical study *World of Our Fathers: The Journey of the Eastern European Jews to America and the Life They Found and Made* (1976). In one of his many influential essays, he wrote, "I think it no exaggeration to say that since Faulkner and Hemingway the one major innovation in American prose style has been the yoking of street raciness and high-culture mandarin which we associate with American Jewish writers."

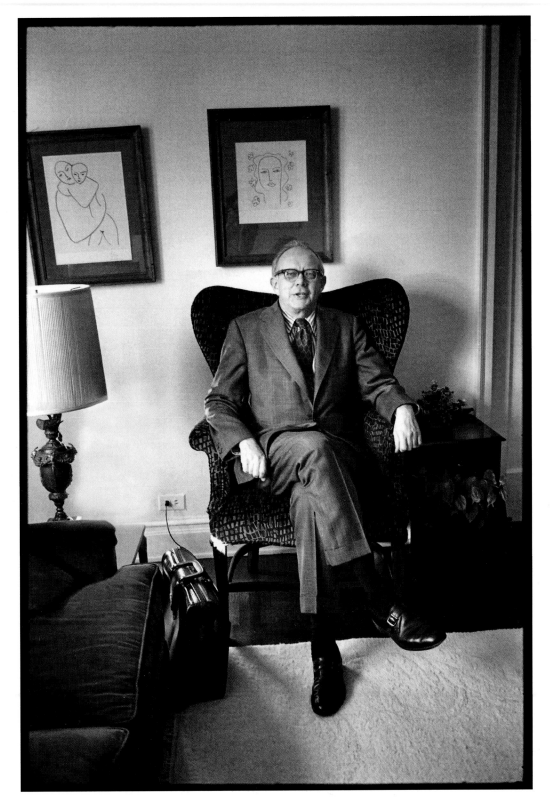

IRVING HOWE
New York City, December 18, 1973

Norman Podhoretz (b. 1930) and Midge Decter (b. 1927) have enjoyed a marriage as intellectual equals for over forty years. Their work comprises a fascinating portrait of ever-changing intellectual and cultural currents. He grew up in Brooklyn and she in Minnesota, and in their teens, they both attended the Jewish Theological Seminary of America. In addition to being an influential young literary critic and the author of the highly controversial memoir *Making It* (1969), Podhoretz was for thirty-five years the editor of *Commentary.* When he first took over the magazine in 1960, he moved it to the left. But about ten years later, having gradually lost faith in the radical ideas to which he had once been committed, both he and the magazine went to war against those ideas. As a social and cultural critic, Decter made the same journey from left to right in her own essays and books, and ever since, the two of them have been leaders of the neoconservative movement— he with works such as *Breaking Ranks* (1979) and *The Present Danger* (1980), she with *The New Chastity and Other Arguments Against Women's Liberation* (1972) and *Liberal Parents, Radical Children* (1975).

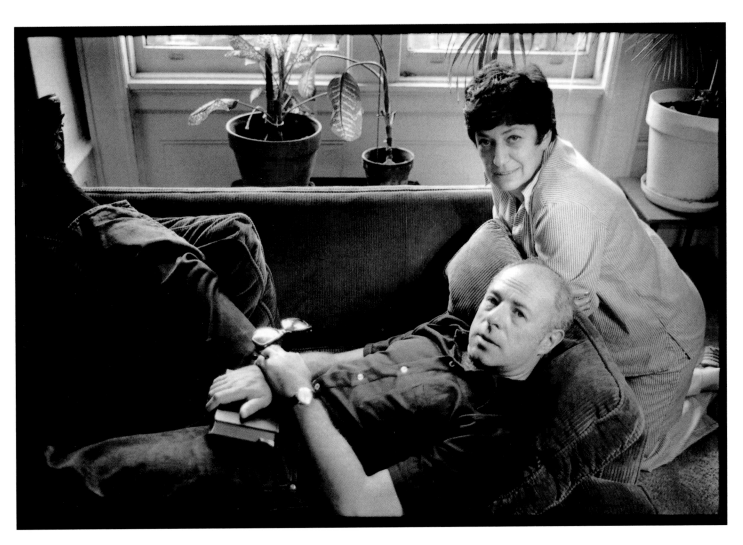

NORMAN PODHORETZ AND MIDGE DECTER
New York City, August 26, 1975

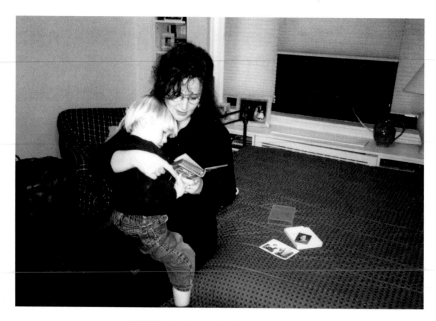

Jill Bialosky with her son, Lucas

Jill Bialosky (b. 1957) is a dazzling poet whose first volume,
The End of Desire (1997), has been described as "graceful, mournful,
often exuberant . . . combining the best aspects of confessional
and lyric poetry." "My poems," she says, "describe the fabric that
has held my family together and often, unwittingly, torn us apart.
Many of the images and details . . . my grandmother's silver,
the Sabbath table at dusk, the braided challah . . . are ornaments
from the past which I use to write about how my family history
impinges upon the present." In her poem "Silver," everyday
things evoke the history of her ancestors:

> *It was this butter knife*
> *my father held in his hand and raised*
> *against his father in anger.*
> *This fork he eagerly brought to his lips*
> *as he listened to the hushed talk*
> *of babies lost and relatives killed in the war.*

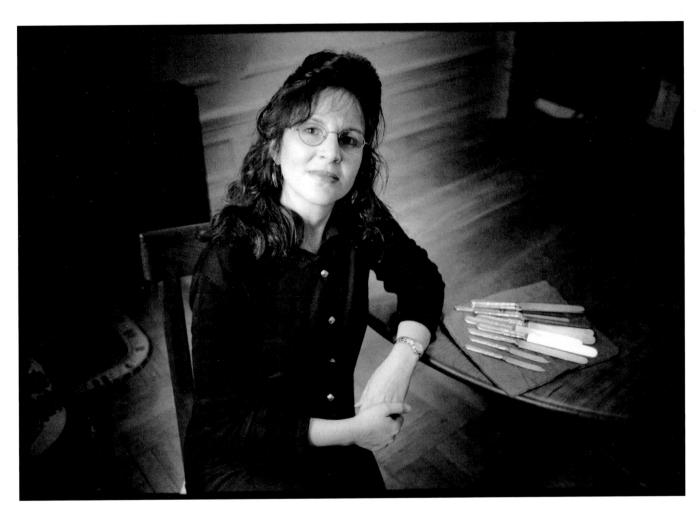

JILL BIALOSKY
New York City, January 17, 1998

Hannah Arendt (1906–1975), one of the commanding intellects of this century, is the author of *The Origins of Totalitarianism* (1951) and *Eichmann in Jerusalem: A Report on the Banality of Evil* (1963). A protégé of Karl Jaspers and Martin Heidegger, she fled Nazi Germany in 1933. Always outspoken and controversial, she was among the first to parcel blame for Hitler's rise among those in Europe who stood aside or cooperated with the Nazis. She wrote, "We can no longer afford to take that which was good in the past and simply call it our heritage, to discard the bad and simply think of it as a dead load which by itself time will bury in oblivion." Interest in her life continues to grow two decades after her death. Recently published volumes of her correspondence with Jaspers and her friend Mary McCarthy have helped convey the warmth of this formidable scholar.

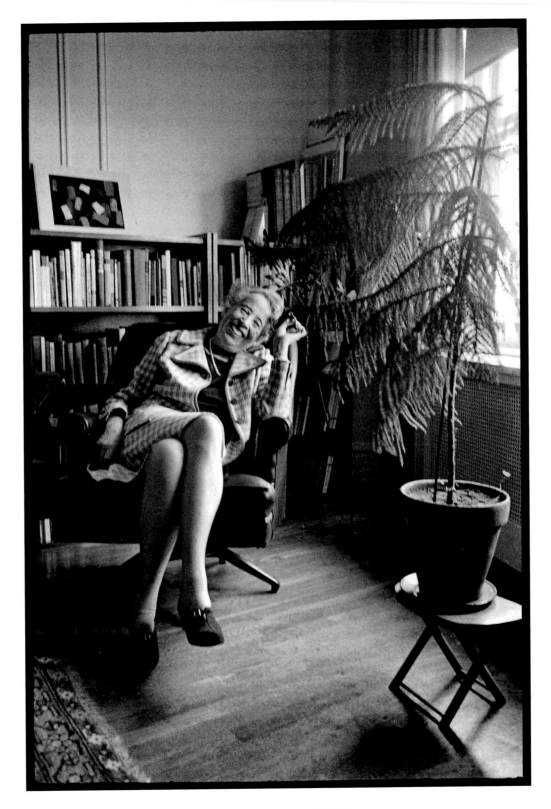

HANNAH ARENDT
New York City, May 1, 1972

They had lived most of their lives in slums
and semi-slums, the East Side, New Lots, and
Williamsburg. Life for children here might be
treacherous, but in those days as well as now
Philip's father refused to accept the conditions
as they were and dumbly submit. Many foreign
parents in these localities, feeling perhaps that
this was America, overlooked their children's
defections, helplessly allowing them to coarsen.
But Philip's father was everlasting in his lectures
on character and proper behavior, and by his
home life, by his own example, he tried to help
his sons retain a sense of integrity.

from *Summer in Williamsburg*

Daniel Fuchs (1909–1993) was a meticulous chronicler of the lives
of Jewish immigrants in Brooklyn during the Great Depression.
His Williamsburg trilogy—*Summer in Williamsburg* (1934),
Homage to Blenholt (1936), *Low Company* (1937)—comprises an
unsparingly honest account of the cramped life in a slum at the
foot of the Williamsburg Bridge. Fuchs focused on the familial
ties and inevitable frictions between two generations of Jewish
immigrants: the father, who accepts the fundamental sadness of
his fate, and the son, who longs for something more, even if it
means breaking away from the family. Like Henry Roth and
Abraham Cahan, to whom he has often been compared, Fuchs
focused on the daily lives of working people. He also had a
distinguished career as a Hollywood screenwriter whose scripts
included *Between Two Worlds* (1944), *Panic in the Streets* (1950),
The Human Jungle (1954), and *Love Me or Leave Me* (1955), for
which he won an Academy Award.

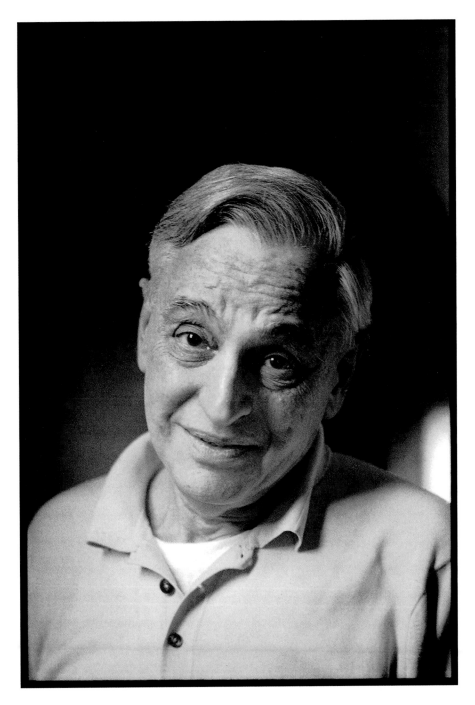

DANIEL FUCHS
Beverly Hills, California, March 24, 1972

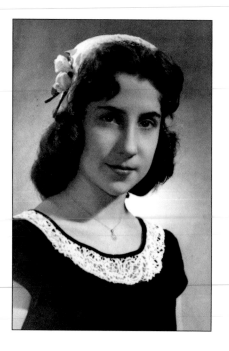

New York City, 1952

This picture was taken in February 1952 to commemorate my bat mitzvah. It was the first and only time I'd ever been brought to a professional photographer's studio for a formal sitting. My bat mitzvah dress was also precedent-shattering: black velvet with a lace neckline, it represented the triumph of modern American ways over old-world fears. Velvet was considered the ultimate in feminine sophistication but, more importantly, to my mother—raised in Hungary with *shtetl* superstitions—black was associated with mourning and was forbidden to children. The fact that she allowed me to wear black for the first time is as memorable to me as anything else related to my bat mitzvah.

Letty Cottin Pogrebin (b. 1939) is a founding editor of *Ms.* magazine, a renowned columnist, political activist, and the author of eight books, including *Deborah, Golda, and Me: Being Female and Jewish in America* (1991), which reconciles the Judaism of her youth with her feminist convictions. In 1952, she was one of the first girls to be bat mitzvahed in Conservative Judaism, and she resumed her study of Hebrew at age fifty. Her writings have focused on Israel, Middle East peace, Jewish feminism, and Black-Jewish relations. Her most recent book, *Getting Over Getting Older* (1996), looks at aging from the Jewish perspective on time.

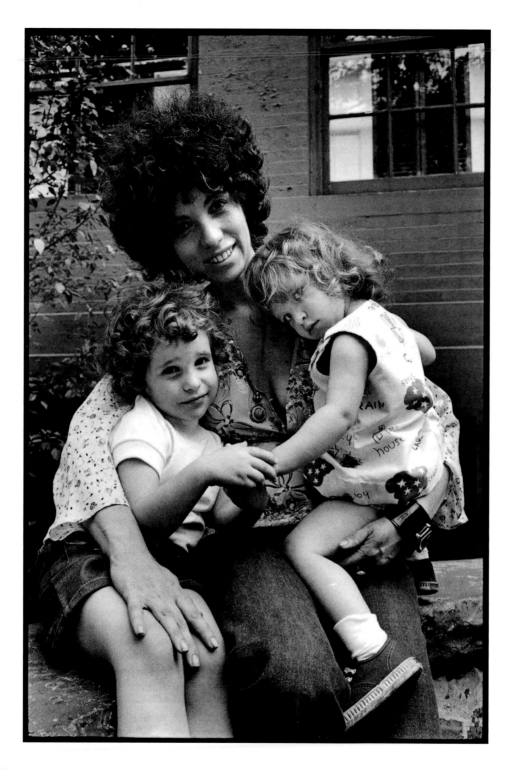

ANNE ROIPHE
with her daughters, Katie and Becky
New York City, June 8, 1972

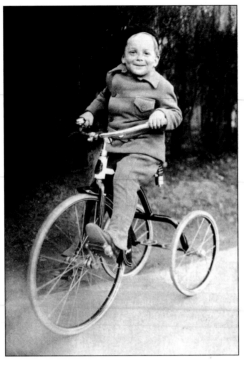

. . . my mother decided to tailor a wool suit for me. I endured many fittings before the thing was done. Early one afternoon of an autumn Sunday I emerged from our house all decked out in a camel-colored tunic and matched leggings and on my head a . . . beret of dark brown. I could feel the grip of the elastic band on my forehead.

I rode up and down the sidewalk for a while on my tricycle. My father joined me a few minutes later and we had a catch. . . . As soon as my mother came out, we would . . . take the bus to my . . . grandma and grandpa. . . .

An itinerant photographer came around the corner and walked toward us with a box camera on a tripod over his shoulder. My father's face lit up. "You've got a customer," he called. . . .

from *World's Fair*

Eastburn Avenue, Bronx, New York, 1936

E. L. Doctorow (b. 1931), whose novels have the distinction of being both popular and critically acclaimed, tends to set his plots in and around New York. Often the action is seen through the eyes of Jewish characters. With *The Waterworks* (1994), portraying the post–Civil War; *Ragtime* (1975), depicting the period before World War I; *Loon Lake* (1980), *World's Fair* (1985), and *Billy Bathgate* (1989), all set in the thirties; and *The Book of Daniel* (1971), which portrays the tormented politicized fifties and sixties, he would seem to have the muralist's sense of the big canvas, with its commingling of past and present, public and private, love of narrative and linguistic figuration. Taken as a whole, his work may be nothing less than a rendering of America's spiritual history.

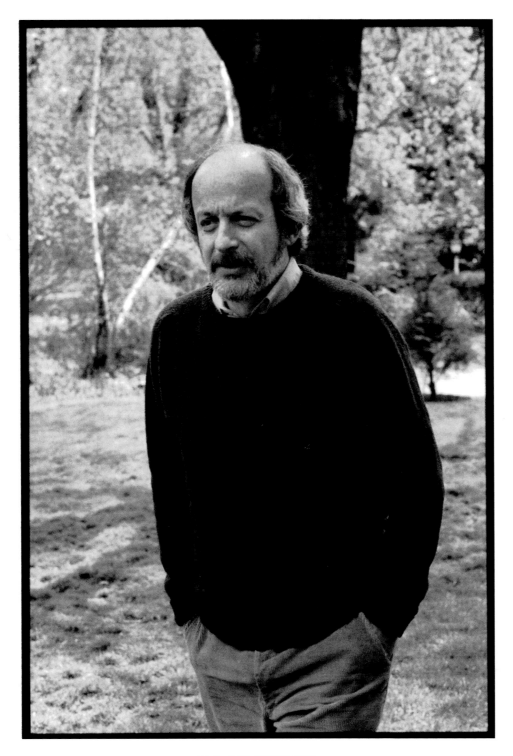

E. L. DOCTOROW
New Rochelle, New York, May 1, 1980

Meyer Levin (1905–1981) was a central and somewhat tragic figure in an ongoing battle over the literary legacy of Anne Frank. In the 1950s, already established as a novelist of Jewish life with such works as *The Old Bunch* (1937) and *Citizens* (1940) as well as a translator and editor of Jewish literary anthologies, Levin became embroiled in what turned into a two-decade effort to produce his own stage adaptation of Anne Frank's diary. His version, *Anne Frank* (1957), focused on the terrible inescapability of the Holocaust and was deemed "too Jewish" for Broadway, while a sanitized "inspirational" version became the popular stage adaptation, later the basis of a popular film. Even while continuing to write wide-selling novels such as *Compulsion* (1956), *The Fanatic* (1964), *The Settlers* (1972), and *The Harvest* (1978)—which Golda Meir called "Meyer Levin's *War and Peace*"—he continued to fight against what he called a blatant attempt to "de-Judaicize the Holocaust." Levin's lawsuit against Anne Frank's father, Otto, was the undoing of his literary reputation. As he admitted in *The Obsession* (1973), "In the middle of my life I fell into a trouble that was to grip, occupy, haunt and all but devour me these twenty years." His son, Gabriel, is a well-regarded Israeli poet and translator.

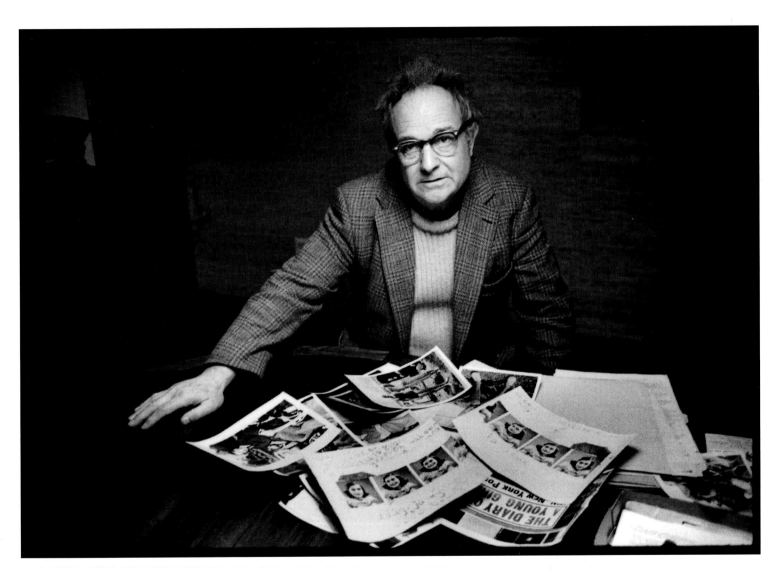

MEYER LEVIN
New York City, January 9, 1974

Robert Pinsky (b. 1940), poet laureate of the United States, has incorporated new areas of American experience into poetry. His book-length poem, *An Explanation of America* (1979), is a unique undertaking that extends and changes the vision of Walt Whitman. His other books include *The Want Bone* (1990), *Poetry and the World* (1990), a collection of literary and autobiographical essays, and a best-selling verse translation, *The Inferno of Dante* (1994). In 1996, he published *The Figured Wheel: New and Collected Poems, 1966–1996.* He writes about his grandfather, a small-town bootlegger and bar owner: "If you told Grandpa Dave that he was in any sense not Jewish, or not Jewish enough, he would laugh. If you suggested that he was ashamed of being Jewish, probably he would be ready to punch you in the face. I cannot think of him as 'assimilated'. . . assimilation suggests protective resemblance to some secure cultural middle, not Grandpa Dave's aggressive ways out on the raffish, sometimes criminal, fringes . . . technically speaking, I would define him as an idolator."

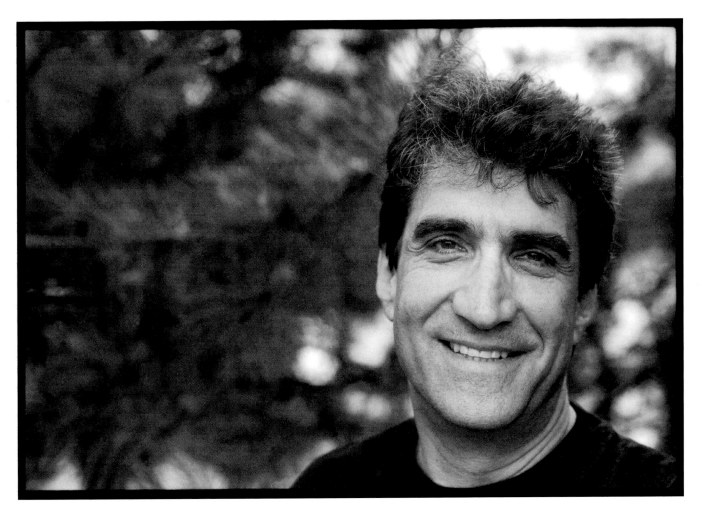

ROBERT PINSKY
Saratoga Springs, New York, July 8, 1996

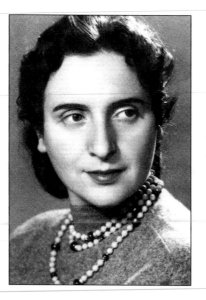

Chava Rosenfarb in Montreal, 1950

What affects me the most is the continual
sense of isolation that I feel as a survivor—an
isolation enhanced by my being a Yiddish writer.
I feel myself to be an anachronism wandering
across a page of history on which I do not
belong. If writing is a lonely profession, the
Yiddish writer's loneliness has an additional
dimension. Her readership has perished.
Her language has gone up with the smoke
of the crematoria. She creates in a vacuum,
almost without a readership, out of fidelity
to a vanished language—as if to prove that
Nazism did not succeed in extinguishing the
language's last breath, and that it is still alive.

Chava Rosenfarb (b. 1923) was born in Lodz, Poland, where she
began writing as a child in the Jewish ghetto under the tutelage
of Yiddish poets, dramatists, and historians. In 1944 she was
deported, first to Auschwitz, then to a labor camp near Hamburg,
and finally to Bergen-Belsen. At the labor camp, a sympathetic
work supervisor smuggled Chava a cotton slip to keep her warm
and a pencil stub, which she hid in her shoe. She had an upper
bunk, and while the other prisoners slept, Chava wrote poems on
the ceiling. As the pencil disappeared, she memorized her poetry,
which made up her first book, *The Ballad of Yesterday's Forest*,
first published in London in 1948. In 1950, Chava emigrated
from Brussels to Montreal, where she turned to prose and spent
thirteen years writing her three-volume masterpiece, *The Tree
of Life*, published in Yiddish in 1972 (English translation, 1985),
a fictional chronicle of life in the Lodz ghetto.

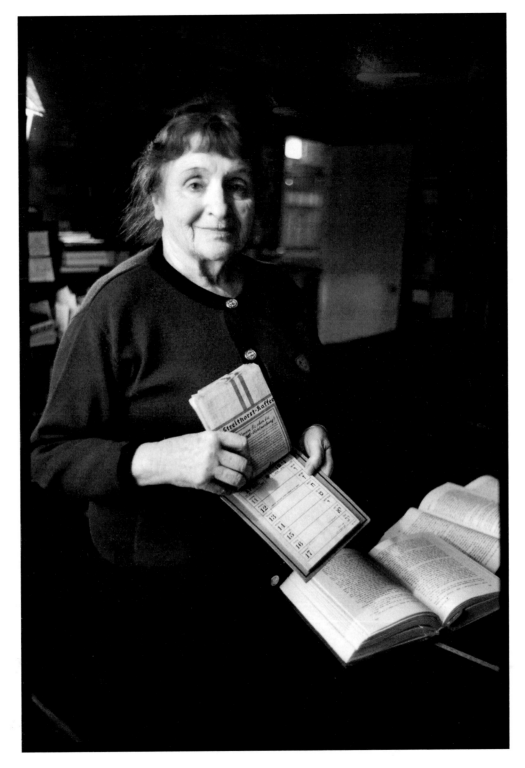

CHAVA ROSENFARB
with a 1943 Lodz ghetto calendar printed on the back of German proclamations
Montreal, Canada, December 12, 1997

I am still a Russian Jew from Riga,
that is how I was born and that is
who I will be to the end of my life.

Sir Isaiah Berlin (1909–1997) was a leading liberal philosopher,
historian, and, for half a century, a prominent and popular
professor of social and political theory at Oxford University.
Born in Riga, Latvia, and a boyhood witness to the February and
October revolutions in Petrograd, Berlin moved with his family
to England in 1919. "He was the last representative of the
passionate, comic, voluble, and morally serious intelligentsia
of old Russia," wrote Michael Ignatieff. "All of these elements,
the Russian, the Jewish, and the English, became relatives in
his soul and they argued together and told jokes to each other
throughout his life." Among his books are *Karl Marx: His Life and
Environment* (1939), *The Hedgehog and the Fox: An Essay on Tolstoy's
View of History* (1953), and *The Crooked Timber of Humanity* (1991).
Berlin was knighted in 1957.

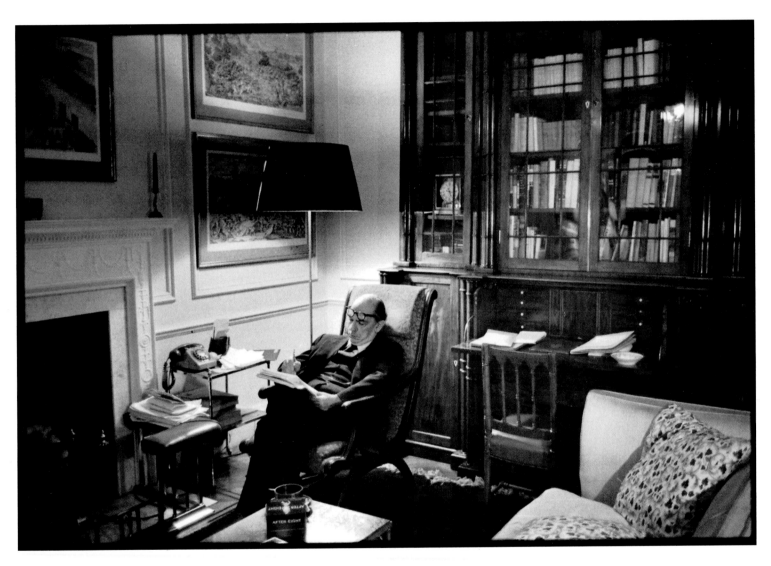

SIR ISAIAH BERLIN
Oxford, England, December 14, 1971

There were platters of meatballs and stuffed derma on the table, too, and a deep, wide bowl of potatoes mashed with chicken fat and fried onions that Gold could have eaten up all by himself.

Ida asked Gold, "What's new?"

"Nothing."

"He's writing a book," said Belle.

"Really?" said Rose.

"Another book?" scoffed his father.

"That's nice," said Esther.

"Yes," said Belle.

"What's it about?" Muriel asked Gold.

"It's about the Jewish experience," said Belle.

"That's nice," said Ida.

"About what?" demanded his father.

"About the Jewish experience," answered Sid, and then called across the table to Gold. "Whose?"

"Whose what?" said Gold warily.

"Whose Jewish experience?"

"I haven't decided yet."

from *Good as Gold*

Joseph Heller (b. 1923) used his combat experiences as a B-25 wing bombardier in World War II to create *Catch-22* (1961), one of a handful of postwar American novels destined to be classics. His second novel, *Something Happened* (1974), perfectly captured the harrowing anxiety of many middle-class family men of our time. *Good as Gold* (1979), his satire of Washington power brokers, created a furor by its depiction of Bruce Gold and his crude attempt to become "the first *real* Jewish Secretary of State," a prize for which no level is too low to stoop. *God Knows* (1984), narrated by Israel's Old Testament King David, explored Jewish themes in a more gentle but still unchastened manner. *Now and Then: From Coney Island to Here* (1998) is Heller's paean to his roots in Brooklyn's Jewish community.

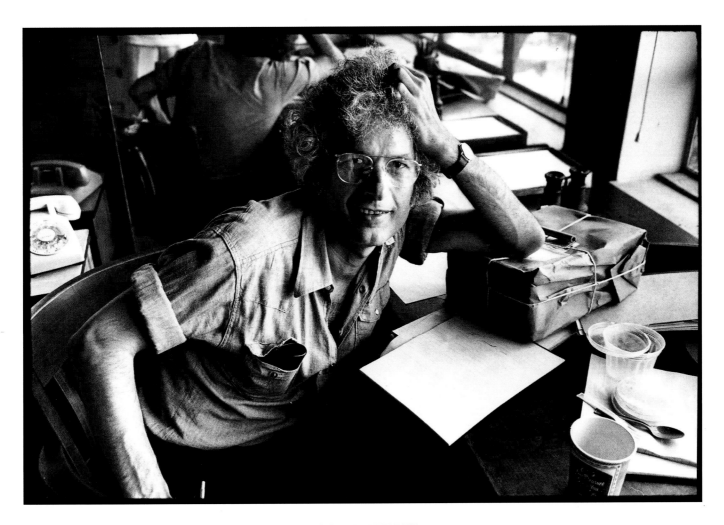

JOSEPH HELLER
with the packaged manuscript of *Catch-22*
New York City, July 2, 1974

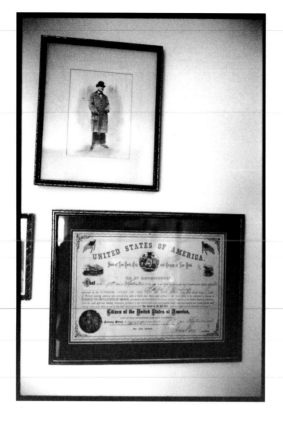

My grandfather came to America in 1875. The blackest days for Jews in Germany were yet to come, so I imagine—since he died when I was two years old and no one ever told me otherwise, I can only imagine—that he left home not out of any terrible desperation but in a youthful spirit of adventure. Dapper in his velvet-collared overcoat, with cigar and cane, he looks almost jaunty, like a man who enjoys life.

"There's never been any place like America," they told me he used to say, "and there never will be again. I kiss this ground."

His citizenship certificate hung in the front hall of his house and remained there long after his death, until it came to me. Now it hangs in the room where I write. It is a long stretch, a long time, from him to me. But in one way or another I have put something of him in all my books.

Belva Plain (b. 1919) has been called the queen of family saga writers. Her first novel, *Evergreen* (1978), is a three-generational story told through the eyes of Anna Friedman, a young Jewish immigrant maid who comes to New York from Poland at the turn of the century and falls in love with her boss's son. It was, says Ms. Plain, questions from her children and grandchildren that inspired her to think about her own Jewish past and then write about the continuity of family life. Most of Belva Plain's sixteen novels have had a Jewish theme. Their settings range from New Orleans before the Civil War (*Crescent City*, 1984) to Wall Street (*Treasures*, 1992), from Holocaust survivors to fifth-generation Americans, from the very religious to the secular, and from the Lower East Side to Fifth Avenue.

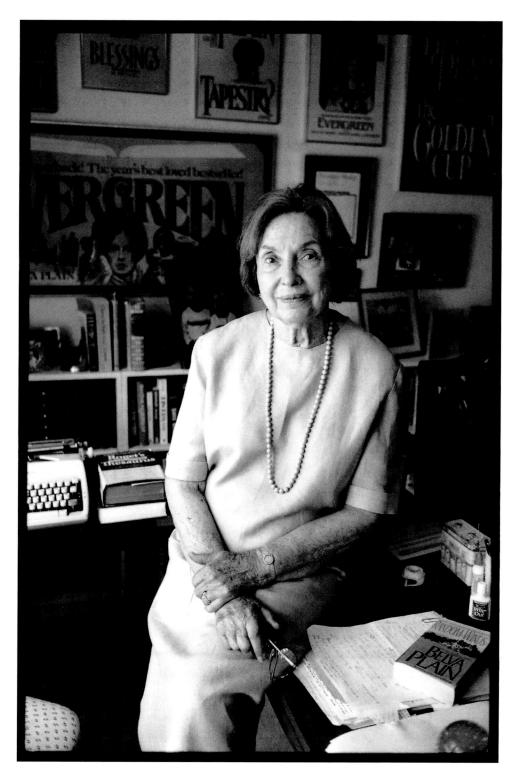

BELVA PLAIN
Short Hills, New Jersey, May 18, 1998

The literary perspective of the Jew is that there is tragedy in the world but that the world must continue: one is a condition for the other. Jews can't afford to revel too much in the tragic because it might overwhelm them. Consequently, in most Jewish writing there's always the caution, "Don't push it too far toward the abyss, because you're liable to fall in."

from a *Paris Review* interview

Arthur Miller (b. 1915) has, over the past half century, won an audience for serious American drama. He began his career as a journalist and novelist, but work with the Federal Theatre Project and on radio plays drew him to the stage. His first success, *All My Sons* (1947), explored the theme that defines his work— parents forced by sons to account for their acts. He followed it with the landmark *Death of a Salesman* (1949), which gave American literature one of its great archetypal characters, Willy Loman. Other plays include *The Crucible* (1953), *A View from the Bridge* (1955), and *The American Clock* (1989).

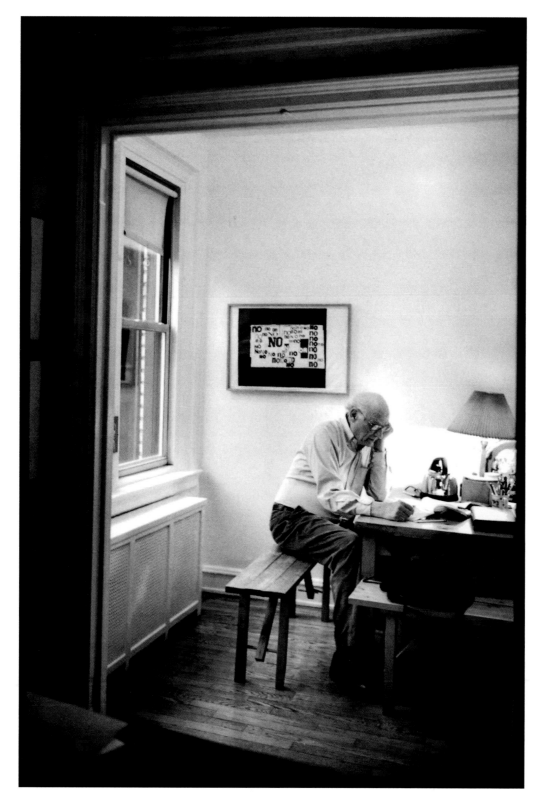

ARTHUR MILLER
New York City, December 5, 1997

"I don't know what Jacob went through in the army,"
his father wrote, "that has done this to him." He never
talks to me about the war. . . . But he has devoured all the
concentration camp reports, and I have found him weeping
when the newspapers reported that a hundred Jews were
killed in Tripoli some time ago.

"The terrible thing is, Norman, that I find myself coming
to believe that it's not neurotic for a Jew to behave like
this today. . . .

"Wherever you go these days—restaurants, hotels, clubs,
trains—you seem to hear talk about the Jews, mean,
hateful, murderous talk. Whatever page you turn to in the
newspapers you seem to find an article about Jews being
killed somewhere on the face of the globe. . . . The day
Roosevelt died I heard a drunken man yelling outside a bar,
'Finally, they got that Jew out of the White House.'. . .

"I find myself looking for Jewish names in the casualty
lists and being secretly glad when I discover them there,
to prove that there at least, among the dead and wounded,
we belong."

<div align="right">

from "Act of Faith"
Short Stories: Five Decades

</div>

Irwin Shaw (1913–1984) had tremendous early success as a socially
conscious playwright with the 1936 antiwar play *Bury the Dead* and
as a short-story writer for *The New Yorker* who served as a model for
an entire generation of writers. Born to Russian-Jewish immigrant
parents, he came of age in a modest home in Depression-era
Brooklyn and went on to lead a glamorous life, first in New York
and Hollywood, then as an expatriate in Paris and Switzerland.
Sailor off the Bremen and Other Stories (1939), his earliest short-story
collection, was notable for its title story and others that vividly
caught the spirit of those troubled times. The story, in which
"the Sailor," a Nazi who assaults a young communist, must face his
brother—an American athlete ready to take him on—won acclaim as
a nearly prophetic microcosm for the war that was soon to follow.
Among the most notable of Shaw's many novels—at one point there
were 14 million copies of his books in print—are the World War II
saga *The Young Lions* (1948) and *Rich Man, Poor Man* (1969).

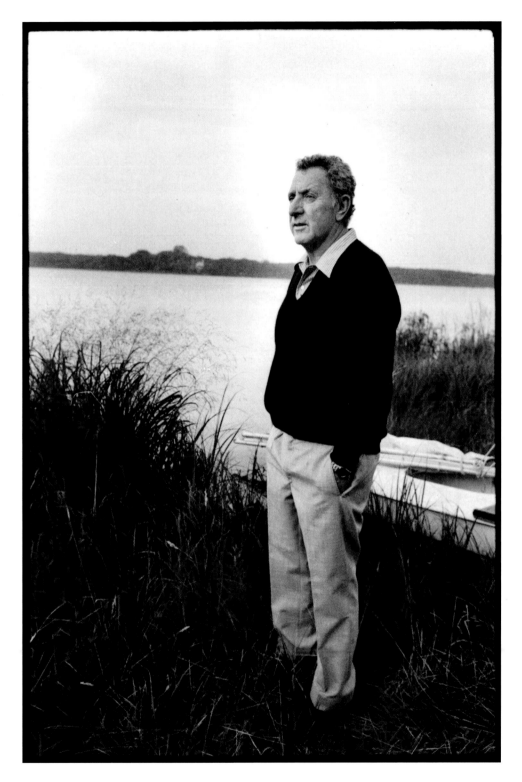

IRWIN SHAW
Wainscott, New York, August 22, 1976

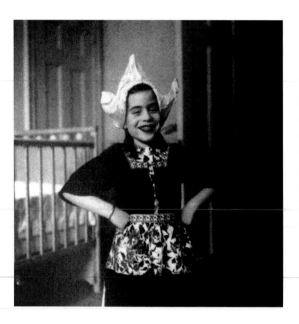

Purim, 1960

When I was five or six, the Dutch girl's costume—
from a trunk full of nurses' uniforms, Southern belle
dresses, policeman and fireman outfits—was the one
that fit me when we dressed up on Purim. Amid the
welter of solemn Jewish holidays, it was only
Chanukah and Purim that kept the interest of children
in mind, and I liked the vision of myself as a smiling
Dutch girl, dressed in wooden clogs and a pointed lace
cap that curled up at the ends like the shoes of a jester.

from *Enchantment*

Daphne Merkin (b. 1954) is well known to readers for her always
engaging essays, film critiques, and articles. Her debut novel,
Enchantment (1986), is the story of an Orthodox Jewish woman in
her twenties, born and raised in New York City, who is alternately
enchanted with and enraged by her mother, a refugee from Nazi
Germany. "I suppose that for tenacious people like me the past
is never really over: what you get left with is the tics of survival,"
writes Merkin. "My childhood clings to me like wet paint."
Her second book, *Dreaming of Hitler: Passions & Provocations* (1997),
is a collection of essays that offers graceful and insightful reflection
on the contemporary intellectual and cultural climate.

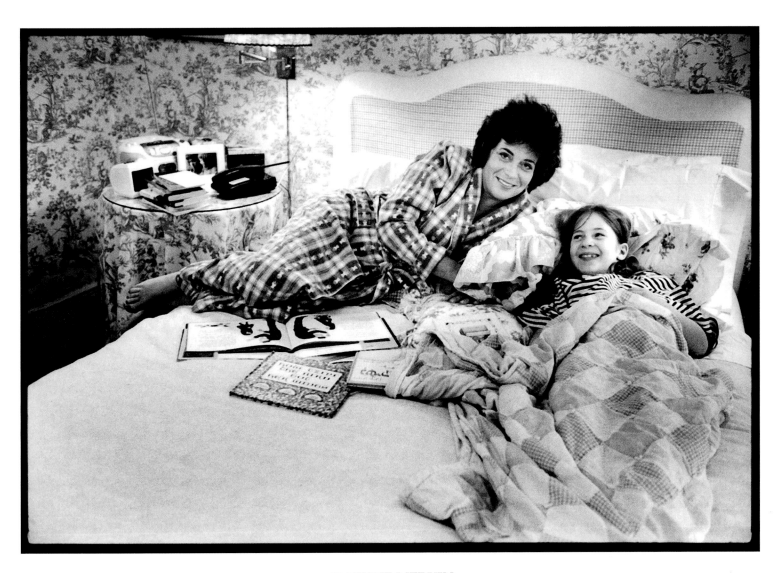

DAPHNE MERKIN
with her daughter, Zoë
New York City, December 7, 1997

And yet, when I look at a page of Talmud and see all those texts tucked intimately and intrusively onto the same page, like immigrant children sharing a single bed, I do think of the interrupting, jumbled culture of the Internet. For hundreds of years, *responsa*, questions on virtually every aspect of Jewish life, winged back and forth between scattered Jews and various centers of Talmudic learning. The Internet is also a world of unbounded curiosity, of argument and information, where anyone with a modem can wander out of the wilderness for a while, ask a question, and receive an answer. I find solace in thinking that a modern technological medium echoes an ancient one.

from "The Talmud and the Internet"

Jonathan Rosen (b. 1963) is the author of the novel *Eve's Apple,* (1997), which *The New Yorker* called "a highly original addition to the distinguished line of Jewish-American family romances." The novel's narrator, when he isn't obsessively trying to unravel the mystery of his girlfriend's self-starvation, teaches English to Russian-Jewish immigrants. In that novel, and in many of his widely published essays, Rosen considers the wounds of prosperity as well as oppression, and the contemporary Jewish-American hunger for recovery and reconnection. Rosen is the culture editor of the *Forward*, a newspaper created one hundred years ago for Yiddish-speaking immigrants, and reinvented in 1990 as an English paper for their descendants. He lives in Manhattan and is married to Mychal Springer, a Conservative rabbi.

JONATHAN ROSEN
at the *Forward* offices
New York City, December 4, 1997

The grave of Reverend Gershom
Mendes Sexas, 1746–1816,
first Rabbi in the United States.
During the Revolutionary War,
this cemetery was fortified by the
patriots as one of the defenses of
the city. It is open to visitors once
a year—on Memorial Day.

Melvin Jules Bukiet (b. 1953) grew up in a *shtetl* that happened
to be located in the middle of New York City. His father and
almost every adult he knew came from the same area of Poland,
arriving in the United States with numbers on their arms.
Bukiet's novel *After* (1996) and his short story collections,
Stories of an Imaginary Childhood (1991) and *While the Messiah
Tarries* (1995), do not, however, directly confront the horrors
of the Holocaust. Instead, they portray the world of his elders
in the prewar years and the broken world after Auschwitz.
Bukiet employs a feverish, darkly comedic style that walks
a fine line between fury and hilarity.

MELVIN JULES BUKIET
at the first Jewish cemetery in the United States, consecrated in 1656
St. James Place in the Bowery, New York City, April 2, 1998

Rosellen Brown (b. 1939), who moves with versatility between novel, short story, and poetry, has written about characters both Jewish and non-Jewish. Her first novel, *The Autobiography of My Mother* (1976), concerns a wandering Alsatian Jew, a wounded woman whose life is defined by exile. *Civil Wars* (1984), set in post–civil rights Mississippi, again places a Jew in history and challenges easy definitions of moral engagement. Her most recent, *Before and After* (1992), locates a New York Jewish family in a small New England town where a horrendous crime, committed by their son, endangers not only their fragile sense of safety as "outsiders" but asks the most profound of biblical questions: Do we owe to other people's children (and by extension, to any stranger) the same protection we owe our own? "I grew up," she writes, "in a household with a typical Jewish preoccupation with social justice. But the working-out of what that means on a daily basis isn't as simple as it sounds, and so my books are my small attempt to trouble the waters—to resist my readers' complacency, and my own."

ROSELLEN BROWN
New York City, May 21, 1995

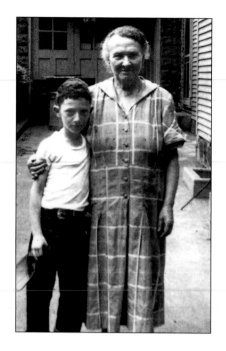

After my sisters reported on the escalator for a second time, Gootie and I decided to make the trip downtown. I might have been five and she sixty, but we had already been a team for a long time. We had an unspoken deal: I would explain America, and she would tell me about Serei.

The escalator came under my domain. We stood on the ground floor and watched the silver steps ascend. Then I tried to explain. Whenever I used the words "electricity" or "motor," Gootie realized that she would never understand. As we looked up at the machine, I didn't understand, either. Both of us were overwhelmed by this thing in the middle of Herpolsheimer's. For a long time we stared at the riders who stepped on and then disappeared from our sight. A constant stream of people rose and then slowly vanished. There was no sound, either.

"Let's go home," Gootie finally said. "This kind of thing isn't for Jews."

from *I Love Gootie*

Max Apple (b. 1941) is an affectionate satirist of American society who, in fiction like *The Oranging of America* (1976), *Zip* (1978), and *The Propheteers* (1987), has created an immensely funny mosaic of pop culture. In his books, the profit motive and crass consumerism go hand in hand with Talmudic parables and political ideals. *Zip,* for example, is about a Jewish manager of a Puerto Rican boxer with the unlikely name of Jesus Goldstein. Apple grew up in a traditional Jewish home, speaking Yiddish as a boy and devouring English in his voracious readings. Being Jewish in a Calvinist midwestern town was, says Apple, "just a different kind of craziness."

He recalls life with his Yiddish-speaking grandparents in two memoirs: in the much praised *Roommates* (1994), he details his coming-of-age alongside his ninety-year-old grandfather; his most recent book, *I Love Gootie* (1998), pays homage to his grandmother, a storyteller and satiric observer of America. She made their hometown in Michigan her Lithuanian *shtetl* and filled her grandson with the stories, ironies, and superstitions that led him to his life as a writer.

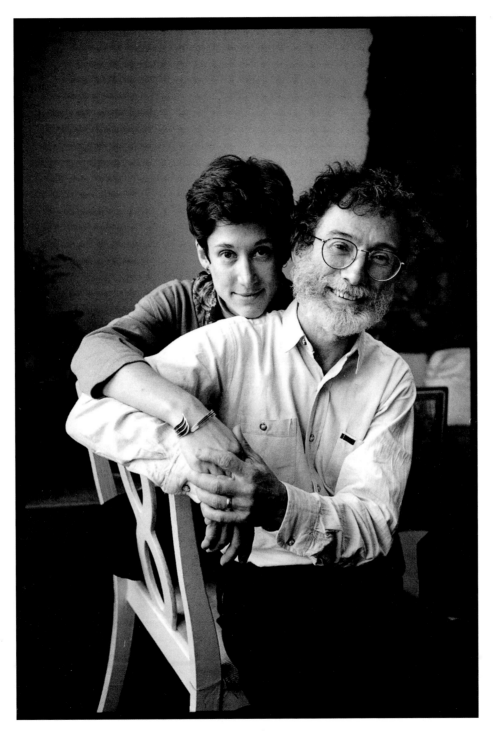

MAX APPLE
with his wife, Talya Fishman
New York City, January 29, 1989

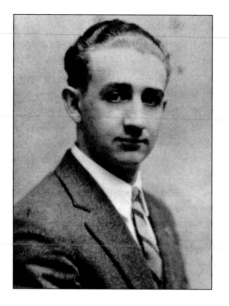

Abe Trillin, circa 1930

When I think of my father's work it's the grocer's constant, often monotonous routines that come to mind: the predawn trips to the city market, the six-day weeks, the regular inventories that ended with both of my parents sitting at the breakfast-room table operating adding machines. . . . In the grocery business it's accepted that one measure of a man's success is raising a son with enough sense to go into another line of work.

from *Messages from My Father*

Calvin Trillin (b. 1935) was born and raised in Kansas City. His memoir *Messages from My Father* (1995) is about how his father, who was born in the Ukraine and raised in St. Joseph, Missouri, transmitted values without appearing to give any direct advice. "You might as well be a *mensch*" was one message. "Don't go around thinking of yourself as a big-shot" was another.

Abe Trillin, first a grocer and later the owner of a small restaurant, taught his son how to play gin rummy and hearts, took him on predawn shopping excursions to the city market, sent him to typing school when he was fourteen, and finally packed him off to Yale. Since 1958, this Missouri *mensch*, called Bud by his friends, has been typing for *The New Yorker, Time,* and *The Nation.* His many books include *Killings* (1984), *Travels with Alice* (1989), and *Remembering Denny* (1993). His most recent, *Family Man* (1998), includes descriptions of ritualistic food shopping with his daughters on the Lower East Side.

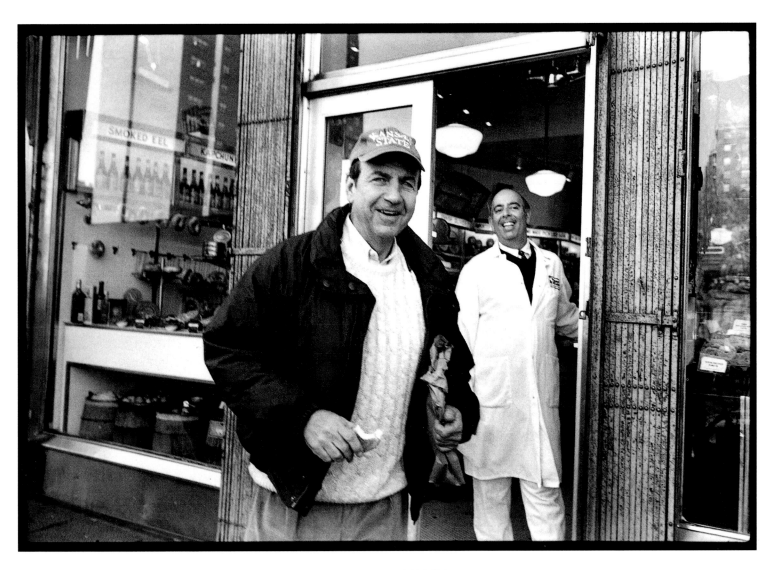

CALVIN TRILLIN
with Mark Russ Federman at Russ & Daughters
New York City, January 22, 1998

Jerzy Kosinski (1933–1991) was as mysterious a person as he was a gifted writer, and his experiences provided the raw material for his novels. He was the only child of Jewish intellectuals in Lodz, Poland. When Hitler invaded in 1939, his parents went into hiding and entrusted young Jerzy to a guardian, who died soon thereafter. Alone, he wandered from village to village until the war's end, when he was reunited with his parents. These experiences were the core of his riveting first novel, *The Painted Bird* (1965), one of the most haunting books to come out of the Holocaust experience. Though educated in Poland, Kosinski wrote his fiction in English, which he quickly mastered after emigrating to the United States in 1957. Other precisely crafted, highly acclaimed novels followed his galvanizing debut, including *Steps* (1968), *Being There* (1971), and *Passion Play* (1979). In 1991, Kosinski—depressed and suffering from a heart condition—committed suicide in his New York apartment.

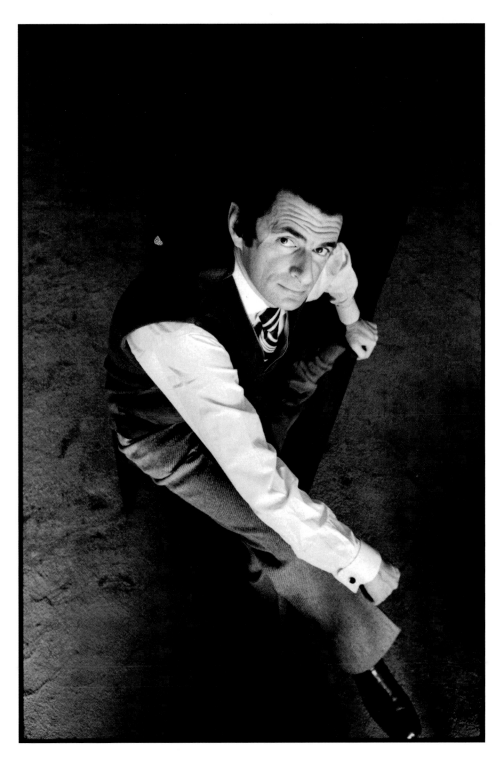

JERZY KOSINSKI
New York City, March 16, 1971

Joseph Machlis (b. 1906) is a gentle literary spirit whose writings on music, including *The Enjoyment of Music: An Introduction to Perspective Listening* (1955) and *Music: Adventures in Listening* (1968), have touched millions. Born in Riga, Latvia, Machlis wanted to be a concert pianist, but after graduating from City College of New York and Juilliard, he asked, "Why am I knocking myself out? I'm not going to make Carnegie Hall." He has explored musical themes and Jewish experiences in five novels, one of which, *Lisa's Boy* (1982), is the tale of a doting Jewish mother who believes her merely competent son to be a world-class concert pianist. *The Career of Magda V* (1985) (based in part on the life of Elizabeth Schwarzkopf) is the story of an opera soprano in Warsaw who survives by singing for Nazi leaders. "The artist is not necessarily a superior human being," said Machlis, explaining the novel's theme. "She's only a superior talent. There may be a conflict between conscience and ambition. . . . It's a very difficult moral question."

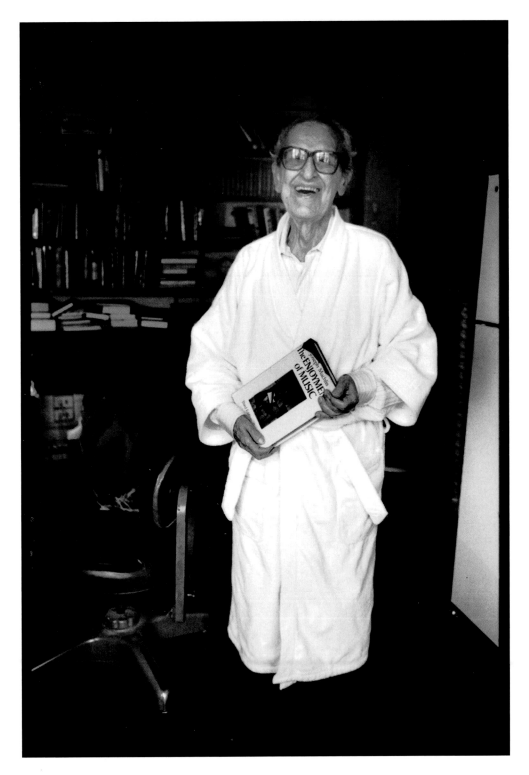

JOSEPH MACHLIS
New York City, December 18, 1997

Dani Shapiro (b. 1962) is the author of three novels: *Playing with Fire* (1990), *Fugitive Blue* (1993), and *Picturing the Wreck* (1996), and the memoir *Slow Motion* (1998). Born in Manhattan and raised in New Jersey, Shapiro is the offspring of an Orthodox family, and her early schooling was at a yeshiva. A third-generation American, Shapiro's subject matter as a writer has tended to focus on the paradoxes of her early life: anti-Semitism, assimilation, rebellion, and the particular dangers of passing. At the age of three, Shapiro was the Kodak Christmas poster child. As a teenager, her parents' friends who had been in concentration camps would call her "little blondie" and say they wished she had been in the camps with them to fetch extra bread from the Nazi soldiers. She watched as her family's home became a target for local anti-Semitic vandals, who screamed epithets late at night. In Shapiro's memoir, she writes of the death of her beloved father in a car crash, and the ways in which mourning him brought her closer to the world she fled as a young woman. The final image in *Slow Motion* is of Shapiro setting a stone—symbolic of continued respect and devotion—on her father's grave.

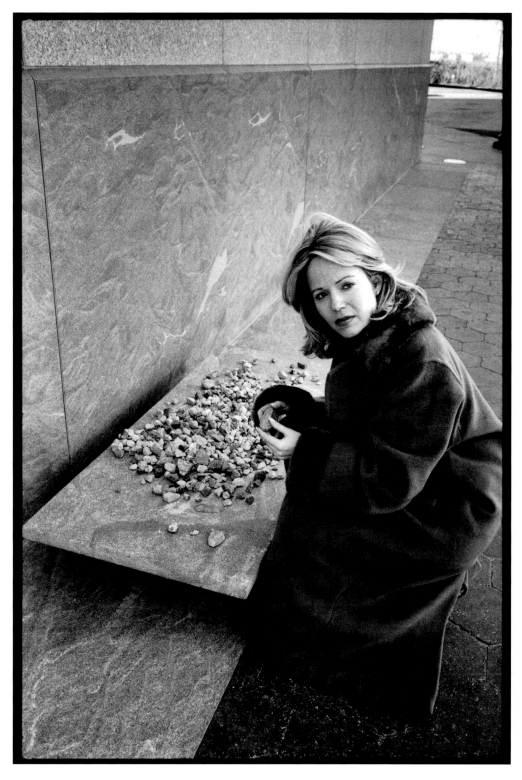

DANI SHAPIRO
at the Museum of Jewish Heritage
New York City, December 21, 1997

David Mamet (b. 1947) has established himself with such brutally truthful works as *American Buffalo* (1977), *Glengarry Glen Ross* (1983), *Oleanna* (1992), and *The Old Neighborhood* (1997). His forte is raw and exact dialogue, as sharp and irrevocably revealing as a sculptor's blade. Mamet is, in fact, as fond of the metaphoric power of knives as he is of whittling wooden animals for his daughters. In *Three Uses of the Knife* (1998), a collection of lectures on the dramatic arts, he argues that playwriting is essentially "the attempt of the orderly, affronted mind to confront the awesome." Mamet has also written numerous film scripts (*Hoffa, The Untouchables, Wag the Dog, The Spanish Prisoner*), as well as works of fiction. His novel *The Old Religion* (1997) focuses on the jailing and death of Leo Frank—the only Jew lynched in American history—and he wrote it, he said, as "an interior monologue of a fellow trying to figure out what it means to him to be a Jew, and the larger question of what it means to be a Jew full-stop."

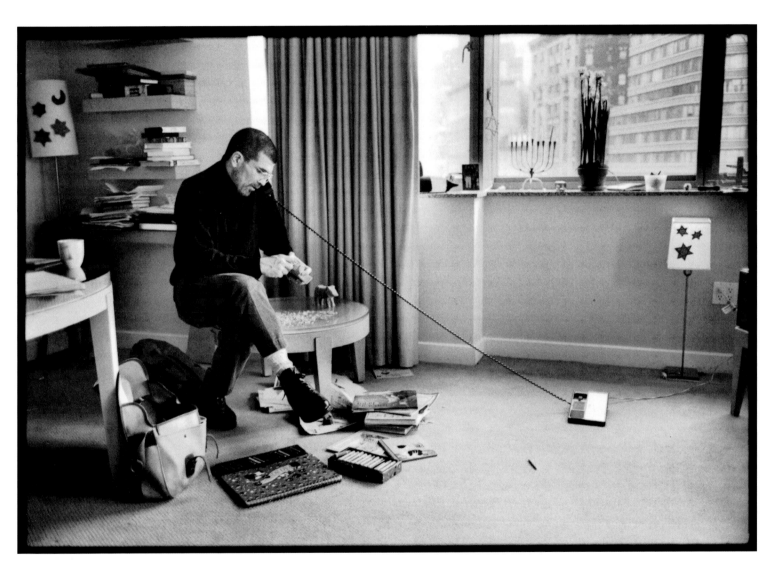

DAVID MAMET
New York City, December 20, 1997

**The Rewedding of Esther and Robert Broner,
a celebration of fifty years together
January 18, 1998, at their loft**

*Behold, thou art fair, my love;
behold, thou art fair;
thou hast doves' eyes.*

*Behold, thou art fair, my beloved,
yea, pleasant:
also our bed is green.*

*The beams of our house are cedar,
and our rafters of fir.*

from Song of Songs

E. M. (Esther Masserman) Broner (b. 1930) is a playwright, novelist, essayist, lecturer, and teacher who describes her work as "the uncharted course of women: their history, genealogy, pilgrimage, literature, connections, and holidays." She combined all of these elements in her masterful and magical novel *A Weave of Women* (1978), the story of fifteen women who share a communal home in the Old City of Jerusalem. The women, like the citizens of Israel, come from all parts of the world and their different lives interweave into a saga of oppression and joy, revenge and celebration. Among Broner's many other writings are two important works of Jewish spirituality, *Mornings and Mourning: A Kaddish Journal* (1994) and *The Women's Haggadah* (with Naomi Nimrod), a highly influential rewriting of the Passover holiday. A standard-bearer for feminism within the Jewish tradition, Broner has, for two decades, urged her "seder sisters" to "always reach for the stars." In *The Telling* (1993), she writes, "We could scarcely know that in a decade the daughters would lead the mothers."

ESTHER M. BRONER
New York City, January 9, 1998

In 1945, a child returning from the Transnistria camps, I was given a book of folktales. I still remember this first gift, its thick, green covers, the magic of that encounter: the word as miracle. Only later, and perhaps inevitably, was I obliged to discover that the word is also a weapon against or in defense of humanity.

from *On Clowns:*
The Dictator and the Artist

On a plaque near *The Holocaust* sculpture, Norman Manea points to the camp where he was interned.

Norman Manea (b. 1936), a survivor of the Holocaust and Romanian totalitarianism, came to the United States in spring 1988. In his fiction, he concerns himself with the trauma of the persecuted individual, daily life in a closed society, and exile. His masterly artistry has been compared to the works of Kafka, Musil, and Bruno Schulz. Manea's colleague and friend Philip Roth has written of him: "Living in a state of emergency furnishes the awful thread of continuity that makes his life and work so distinctively harrowing." His works include a collection of stories, *October Eight O'Clock* (1992); essays relating to life in Romania under the Ceausescu regime, entitled *On Clowns: The Dictator and the Artist* (1992); and the novel *The Black Envelope* (1995), which details the daily terrors of Bucharest in the 1980s.

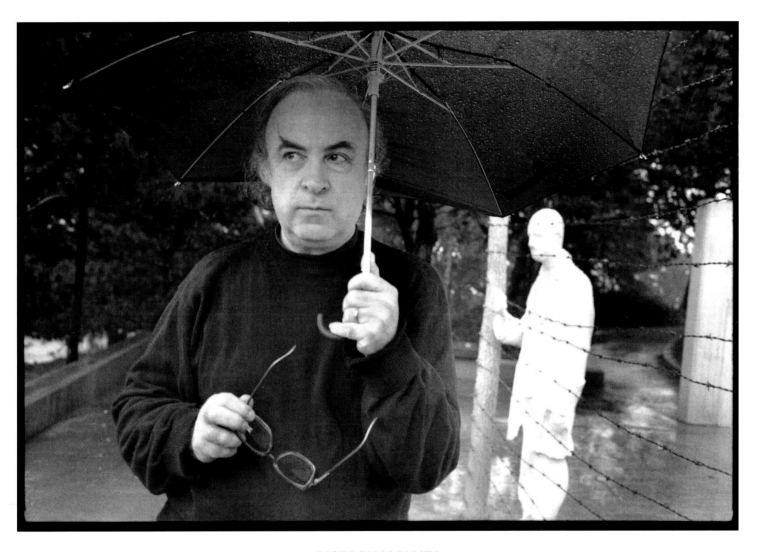

NORMAN MANEA
in front of George Segal's sculpture *The Holocaust*
Golden Gate Park, San Francisco, California, February 2, 1998

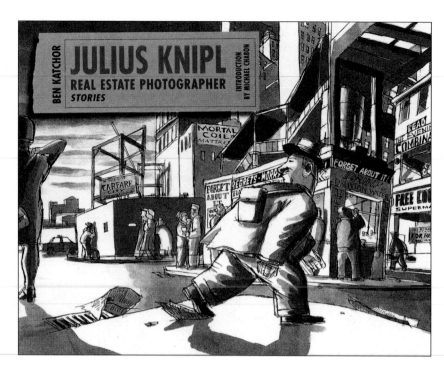

Cover of the collected "Knipl"

Ben Katchor (b. 1951) has redefined the art of the comic strip, elevating it to the level of literature in "stories" such as *Julius Knipl, Real Estate Photographer* and *The Jew of New York.* Katchor's stories are told over the course of eight panels that follow the city rambles and inner ruminations of a rumpled man named Julius Knipl (*knipl* is "nest egg" in Yiddish). His work is in national syndication and appears weekly in the *Forward,* and he has been profiled in *The New Yorker* by Lawrence Weschler, who said Katchor "has been doing for comics what Marcel Proust once did for the novel." In his introduction to the collected "Knipl" (1996), novelist Michael Chabon makes a convincing case that Katchor is the best comic strip "writer" since George "Krazy Kat" Herriman. "His polished, terse and versatile prose is capable, in a single sentence strung expertly from a rhythmic frame of captions, of running from graceful elegy to police-blotter declarative to Catskill belly rumble."

BEN KATCHOR
New York City, January 3, 1998

Johanna Kaplan (b. 1942) writes about the thorny, diverse lives and relationships of Jews in—and with—America. In her short-story collection, *Other People's Lives* (1975), and her novel, *O My America!* (1980), her characters are people for whom the highly freighted past, both collective and individual, has a bewildering way of peeping over the shoulder of the present. Whether she is writing about a naive hippie who can't utter a complete sentence, or a sophisticated intellectual who can make complex public speeches at the drop of a hat (and does), Kaplan writes with sharp comedic insight and high-spirited moral grit. If Kaplan's work reflects a musician's perfectly pitched ear for the nuances of speech, it can probably be attributed to her own musicality: "Before I learned to talk I used to go to synagogue with my grandfather, who was the cantor. I sat up on an enormous chair on the *bimah* and my baby's voice rang out in prayer."

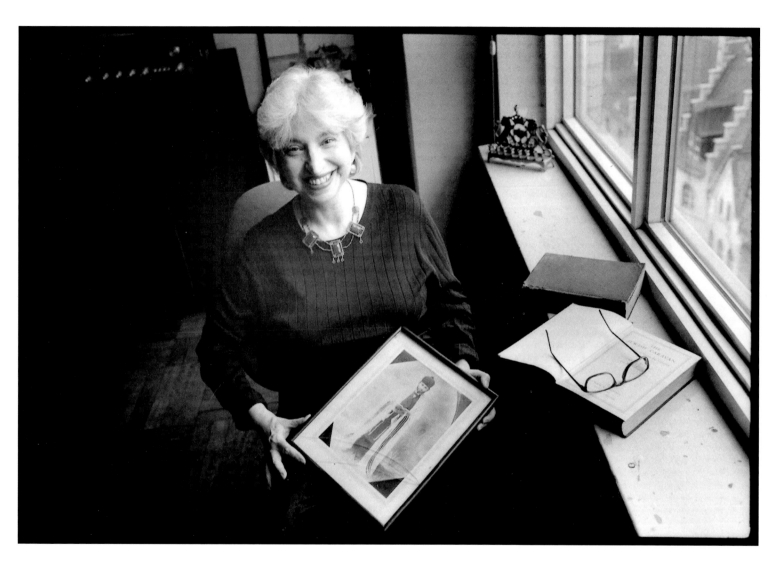

JOHANNA KAPLAN
New York City, February 17, 1998

I thought of my parents of blessed memory, and all at
once I felt a great desire to say the kaddish for them in the
Holy Land and to pray for their souls. And so I asked my
son if there might be a village nearby with enough Jews
in it for a prayer group. At first he was as startled as if I
had asked him to pluck a star from the sky. *"Jews? Here?"*
"And is there anywhere without them?" I marveled.
He cocked his head and stared at me, and then he smiled
a bit. . . .

 He ducked through a gap in the prickly pear hedge
and stepped into some mud huts, from which he pulled
out one shadowy form after another and brought them
to me. I looked about me and saw these dark-faced,
bare-legged Ishmaelites, some with battered fezes on
their heads and some with black keffiyehs, most silent
and docile, as if they had just been torn out of their first
sleep. "Here, *Papá,*" says Yosef, "here is your *minyan.*" He
frightened me. "But who are these men, son?" I asked him.
 . . ."these are Jews, *Papá,* they just don't know it yet. . ."

<div align="right">from Mr. Mani</div>

A. B. Yehoshua (b. 1936) was born and schooled in Jerusalem and
is now a distinguished literature professor at Haifa University as
well as one of Israel's most celebrated writers. His controversial
stories, plays, and novels are loving but unflinching examinations
of the dream, the promise, and the realities of Israeli society.
His first novel, *The Lover* (1978), caused some heads to turn for
its symbolic dissection of Zionism, and his second, *A Late Divorce*
(1984), was a cogent look at the pathological relationship inside
the Israeli family. *Mr. Mani* (1992) examines six generations
of Jewish history through conversational reminiscences of
one family.

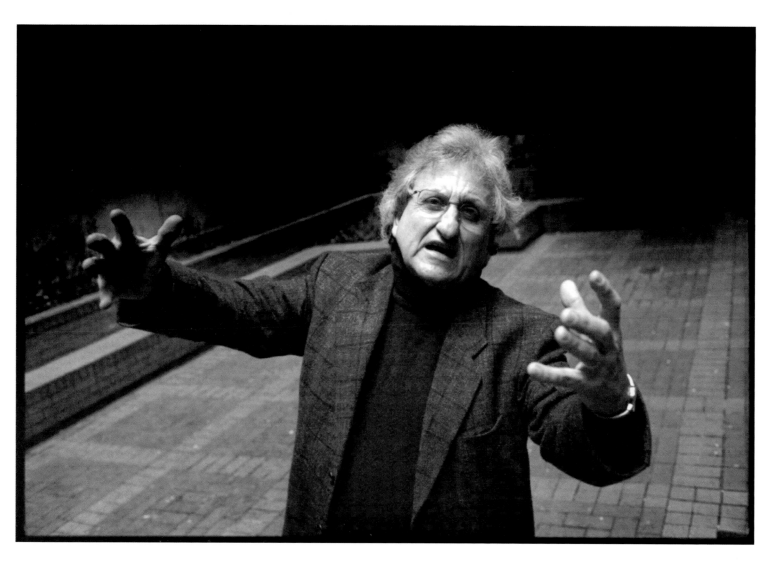

A. B. YEHOSHUA
New York City, March 7, 1998

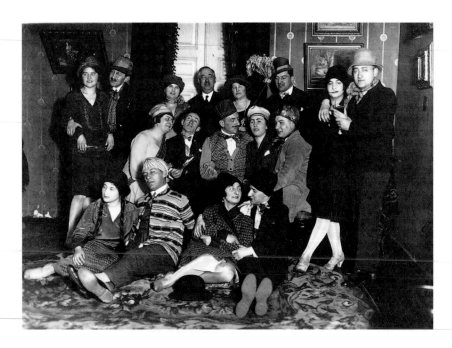

A lost world: Clowning in Vilna, Lithuania, in 1928, during a visit by the
Vilna Troupe, a theater ensemble. Masha Roskies, Ruth Wisse's mother,
is the second person from the right.

Ruth R. Wisse (b. 1936) grew up in a culturally vibrant Montreal
household where Yiddish was one of several spoken languages. After
helping to found the Jewish Studies Program at McGill University,
Wisse became the first Professor of Yiddish and Comparative
Literature at Harvard. She is notable for her perspective on Yiddish
as the vehicle of one of the great European national literatures and
for her striking analyses of Jewish history and the direction of the
Jewish future. She is the author of literary studies including *The
Schlemiel as Modern Hero* (1970) and *A Little Love in Big Manhattan:
Two Yiddish Poets* (1988), personal essays, and political writings,
most distinctively *If I Am Not for Myself: The Liberal Betrayal of the
Jews* (1992). She is the rare and heroic original: a fearless intellectual.

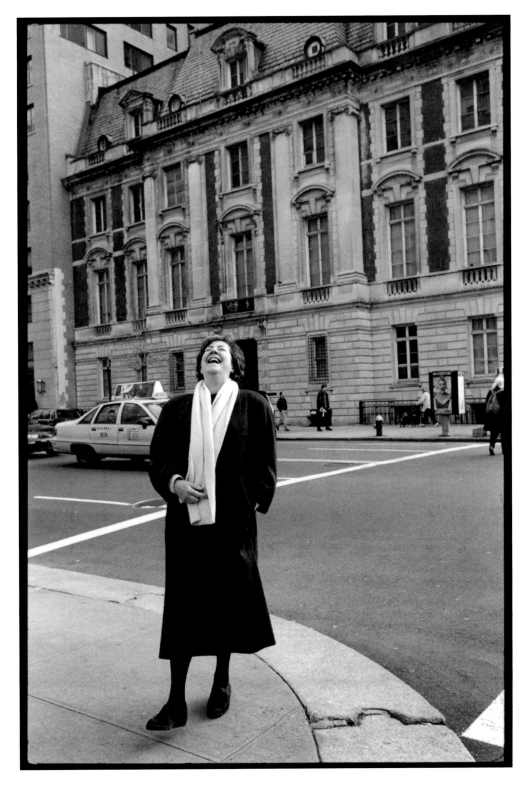

RUTH R. WISSE
in front of the former YIVO building at Fifth Avenue and 86th Street
New York City, February 22, 1998

The first time I saw him he couldn't have been much more than sixteen years old, a little ferret of a kid, sharp and quick. Sammy Glick. Used to run copy for me. Always ran. Always looked thirsty.

"Good morning, Mr. Manheim," he said to me the first time we met, "I'm the new office boy, but I ain't going to be an office boy long."

"Don't say ain't," I said, "or you'll be an office boy forever."

"Thanks, Mr. Manheim," he said, "that's why I took this job, so I can be around writers and learn about grammar and how to act right."

from *What Makes Sammy Run?*

Budd Schulberg (b. 1914) was born a "Hollywood Prince," the son of Paramount studio chief B. P. Schulberg. Witnessing Hollywood's highs, lows, and excesses throughout his father's topsy-turvy career, he moved on to become a novelist and screenwriter. In the mogul Sammy Glick, hero of his seminal Hollywood novel, *What Makes Sammy Run?* (1941), Schulberg created an American icon. At the end of World War II, after serving in John Ford's OSS/Navy film unit in Europe, Captain Ford put him in charge of gathering and presenting photographic evidence used in the Nuremberg Trial in 1945–1946. His screenplays include *On the Waterfront* (1954), winning him an Academy Award, and *A Face in the Crowd* (1957). Among his other well-known novels are *The Harder They Fall* (1947), the story of a mob-owned prizefighter, and *The Disenchanted* (1950), whose alcoholic central character is based on F. Scott Fitzgerald. Schulberg revisits his "Home Sweet Hollywood" in the memoir *Moving Pictures* (1981).

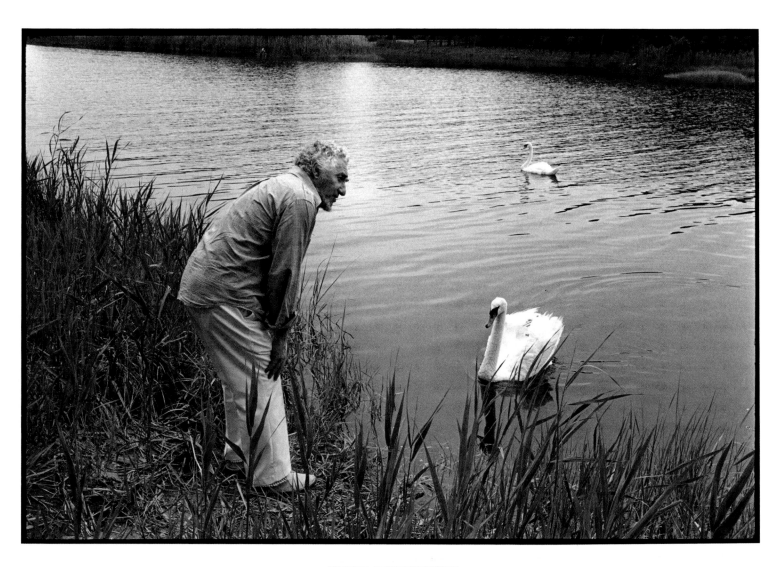

BUDD SCHULBERG
Westhampton Beach, New York, July 27, 1974

The lonely days were Sundays—Sundays when
I watched the town people going to church,
while we stayed upstairs in our apartment.
Then I would feel like an outsider in this little
community. I would have hunger in my heart for
my own people. I would visualize a Utopia—a
village like this of all Jews—going to temple on
the Sabbath.

—Jennie B. Nachamson, Eli Evans's
grandmother, recalling her life in
the early 1900s

Eli N. Evans (b. 1936) is a storyteller and a historian, capturing
the interior landscape of what he has called "a unique Southern
Jewish consciousness." His books are a revelation, at once history
and memoir, evoking the rhythms and heartbeat of Jewish life
in the southern United States. He is the author of the enduring
classic *The Provincials: A Personal History of Jews in the South* (1973)
and a Civil War biography of the first acknowledged Jew in the
U.S. Senate, *Judah P. Benjamin: The Jewish Confederate* (1988). In his
book of essays, *The Lonely Days Were Sundays: Reflections of a
Jewish Southerner* (1993), Evans points out that Jews and
Southerners are very much alike, "stepchildren of an anguished
history," but with differences, too. His writing explores the
contradictions in the Jewish Southerner, who has inherited the
Jewish longing for a homeland while being raised with the
Southerner's sense of home.

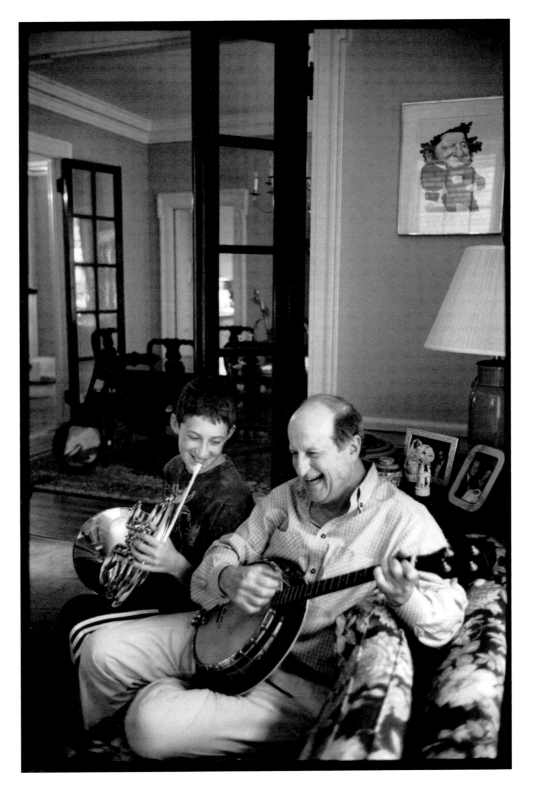

ELI N. EVANS
with his son, Joshua
New York City, January 19, 1998

When I was a child I sang in the synagogue choir,
I sang till my voice broke. I sang
first voice and second voice. And I'll go on singing
till my heart breaks, first heart and second heart.
A psalm.

"Psalm," from *The Selected Poetry*
of Yehuda Amichai

Yehuda Amichai (b. 1924) is a German-born Israeli poet whose reverential lyricism bridges the gap between the personal and the universal, as well as ancient and modern Jewish history, to produce timeless literature. His verse—written in Hebrew—has reached a wide readership in French, Swedish, Spanish, and English translations. Among the latter are *The Early Books of Yehuda Amichai* (1988), *Even a Fist Was Once an Open Palm with Fingers* (1991), *A Life of Poetry, 1948–1994* (1994), and *The Selected Poetry* (1996). "I grew up in a very religious household," Amichai told the *American Poetry Review.* "So the prayers, the language of prayer itself became a kind of natural language for me."

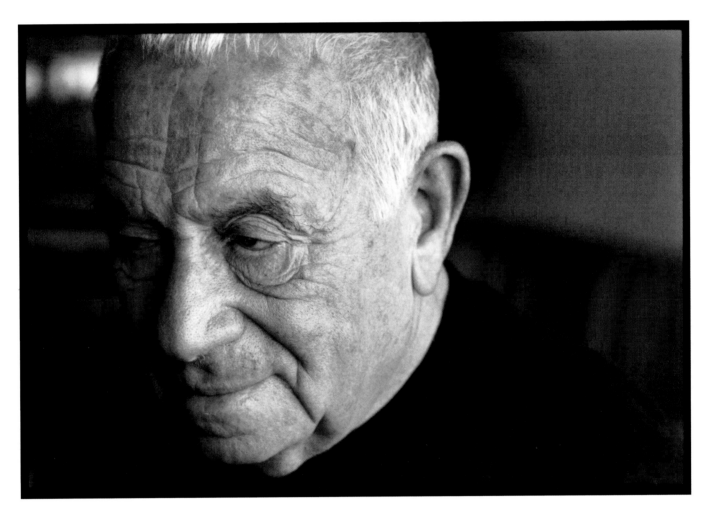

YEHUDA AMICHAI
New York City, March 26, 1998

"So," God said, "what do you make of Me, eh?
What do you make of Me now you understand
that finally it takes two to break a contract as
well as to make one? What do you make of Me
Who could have gotten it all right the first time,
saved everyone trouble and left Hell unstocked?
Do you love Me? Do you forgive and forget as
easily as I do? Do you?"

from *The Living End*

Stanley Elkin (1930–1995) was a seriously funny novelist with
a penchant for wild settings and linguistic fireworks. He was a
writer's writer, whose numerous works—including *Criers and
Kibitzers* (1966), *Searches and Seizures* (1973), and *The Rabbi of Lud*
(1987)—went underappreciated. In *The Dick Gibson Show* (1971),
about a small-town talk-radio host, Elkin presaged by two
decades the current multimedia obsession with gut-spilling.
"It is a frenzied parable," wrote John Leonard, "rather as though
the Wandering Jew and Willy Loman had gotten together on a
vaudeville act." *George Mills* (1982) was the sardonic portrait of
a furniture mover in St. Louis who magically retraces his Jewish
roots back to the Crusades. "And remember," he writes, "that
cruelty is as real a legacy as the family silver." His seventeenth,
and final, novel, *Mrs. Ted Bliss* (1995), is the story of a Miami
Beach widow who reinvents her life, much to her own surprise.

STANLEY ELKIN
American Academy of Arts and Letters
New York City, May 21, 1986

Jewish stories filled my childhood. My parents read me Lillian S. Freehof's *Stories of King David* and *Stories of King Solomon,* and Sadie Rose Weilerstein's *Adventures of K'tonton,* stories of a Jewish Tom Thumb. My father told me the story of Joseph and the story of Moses leading the Jewish people out of Egypt, and he read Sholem Aleichem's *Kasrilivke Tales* aloud to our family while I rolled around on the floor laughing. My dream as a child was that someday I would read my own stories to my parents. That dream came true. Now I dream that my children will read their stories to me.

Allegra Goodman (b. 1967) burst onto the literary scene with *Total Immersion* (1989), a collection of unusually mature stories, published while she was still a senior at Harvard, that prompted Cynthia Ozick to exclaim, "All the muse-fairies were present at her birth!" She followed it with *The Family Markowitz* (1996), a series of linked and gently funny tales of an eccentric Jewish family that survives modern malaise by embracing tradition. The same holds true for the author, who described her Judaism to *The New York Times* as "traditional, somewhere between Conservative and Orthodox." Her first novel, *Kaaterskill Falls* (1998), is about a Jewish summer community in the Catskills.

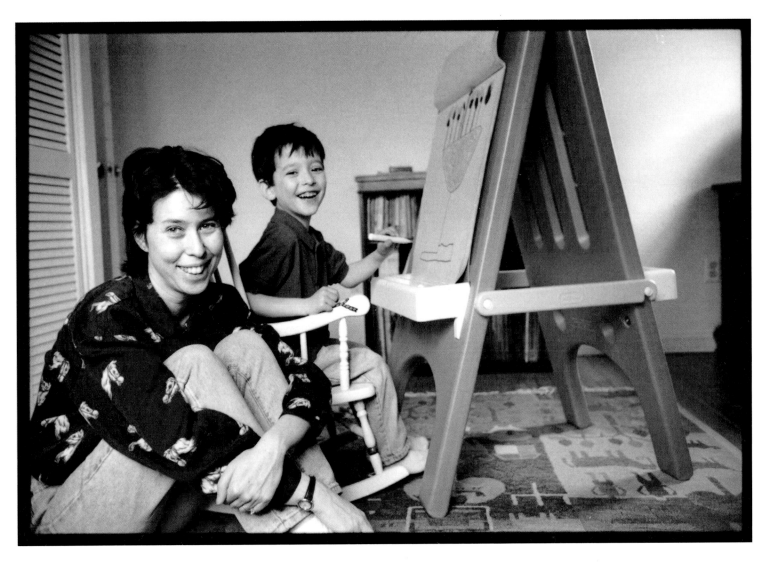

ALLEGRA GOODMAN
with her son, Ezra
Cambridge, Massachusetts, April 13, 1997

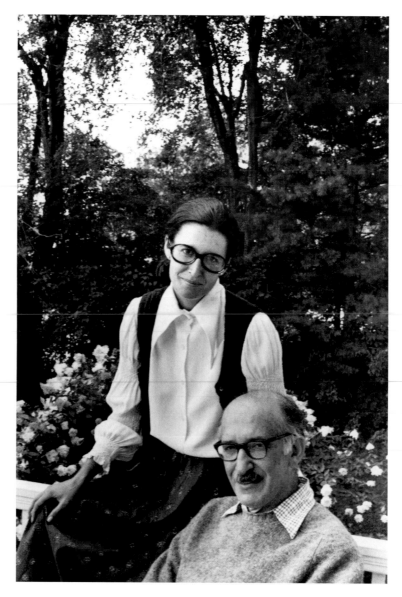

Jill Krementz and Bernard Malamud
Bennington, Vermont, August 21, 1971

Jill Krementz is one of America's most acclaimed photojournalists, displaying a passionate and unique visual style. Her best-selling photo-essay books, which include the *Very Young* and the *How It Feels* series, have inspired and informed both children and adults. For the past three decades, she has been recognized as one of this century's premier portraitists of writers. This is her thirtieth book.